The Plains Indian Photographs of Edward S. Curtis

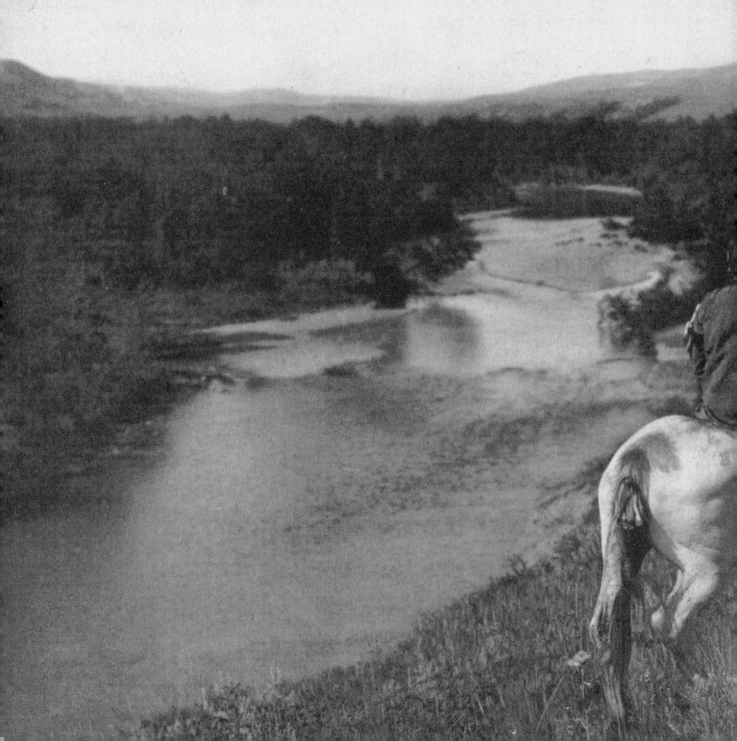

The Plains Indian Photographs

of Edward S. Curtis

UNIVERSITY OF NEBRASKA PRESS
Lincoln and London

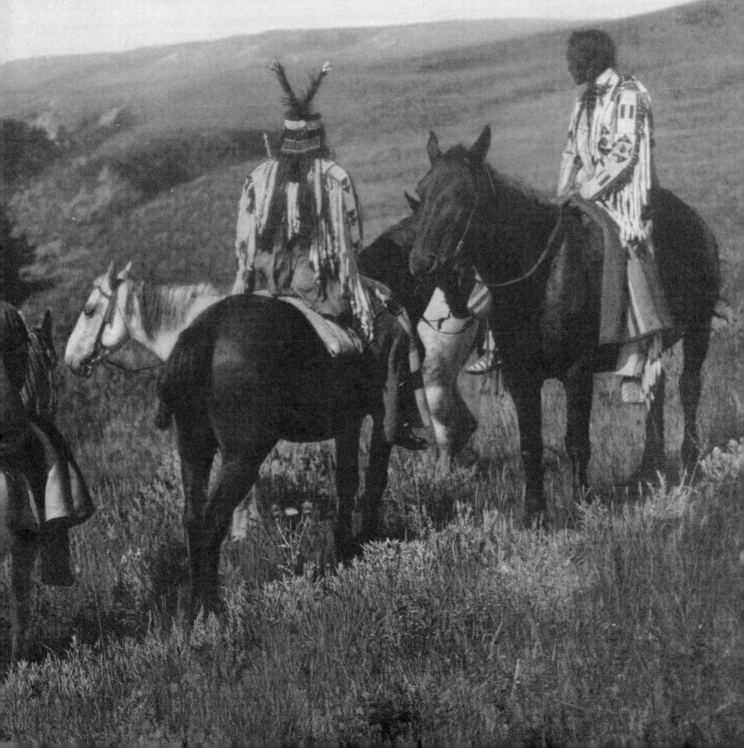

Publication of this book was assisted by a grant from the University of
Nebraska Foundation.

♾

Library of Congress Cataloging-in-Publication Data
Curtis, Edward S., 1868–1952.
 The Plains Indians photographs of Edward S. Curtis / Edward S. Curtis.
 p. cm.
 Includes bibliographical references.
 ISBN 0-8032-1512-6 (cloth : alk. paper)
 1. Indians of North America—Great Plains—Portraits. 2. Indians of North
America—Great Plains—Pictorial works. 3. Curtis, Edward S., 1868–1952—
Photograph collections. I. Title.

 E78.G73 c874 2001
 779'.2'08997—dc21
 00-034395

Contents

Photographs

The Plains Indian Photographs of Edward S. Curtis

Introduction

MARTHA H. KENNEDY

Edward S. Curtis (1868–1952) devoted over thirty years to photographing and studying the indigenous peoples of North America. The published result of his labors, *The North American Indian* *(1907–1930)*, consists of twenty volumes of large photogravures and twenty corresponding volumes of illustrated text on more than eighty tribal groups living west of the Mississippi and Missouri Rivers. This monumental work made Curtis arguably the best-known photographer of American Indians. It has exerted an enduring influence on American culture and inspired numerous popular and scholarly books, articles, and photographic exhibitions. The present volume grows out of an exhibition and symposium that focused on the photographer's imagery of Plains Indians. This focus has broad appeal and significance in part because of a widespread tendency to regard Plains Indians as representative or emblematic of all American Indians. Although Curtis's work on the peoples of this region constitutes less than one-third of his multivolume publication, we learn a great deal about the meanings and intentions behind the entire project when we study this portion. His photographs also underscore the rich variety of Plains Indian peoples themselves.

The ninety-one photogravures reproduced in this book have been selected to complement the essays and focus upon Curtis's impressive visual chronicle of Plains Indian societies.[1] The photographer's pictures and texts raise many questions. What were his stated intentions and how well did he succeed in fulfilling them? What historical and cultural forces were important in shaping his photographic approach? Was his approach unique? How do the images and accompanying words work together? The three essays address these questions in varying ways, thus illuminating different facets of Curtis's work and career.

Martha A. Sandweiss, associate professor of American studies and history at Amherst College in Massachusetts, observes that the underlying concept of Curtis's work was not unique. In her essay in this volume, she defines and analyzes two established photographic traditions of portraying American Indians prior to Curtis—one ideological, the other commercial—and thereby establishes the historical pictorial context within which he worked. Curtis believed in and promulgated a vanishing-race ideology that helped shape the content of his imagery. In producing this great body of work, he also followed "a tradition of marketing Indian images as public and didactic photographs." Sandweiss demonstrates how such imagery served the commercial and political needs of the photographers who preceded Curtis. Finally, she considers the difficult issue of how Indian subjects perceived their position in their encounters with photographers and whether they always served solely the photographers' agendas. Sandweiss strongly suggests that some Indian subjects probably viewed being photographed as "part of a fair economic exchange" that met their needs and not simply those of the photographers.

Mick Gidley, professor of American literature at the University of Leeds in England, closely examines the workings of the Curtis project with reference to the plains images, contextualizing them in broad historical and cultural terms. Curtis believed that he was making a truthful, straightforward record of American Indians' traditional ways of life. Gidley explains how this was not an attainable goal for Curtis or anyone else: any records that aspire to being documentary do not constitute reality but representations of it. He details the complexity of Curtis's project, emphasizing and clarifying that it was a collective endeavor. Further, he contends convincingly that Curtis's work conceals the very

processes by which it was produced, thereby giving the viewers and readers the impression that they have entered a different but seamless world of tradition. Drawing on extracts from little-known documents, Gidley illuminates the actual conditions under which some of the images of Plains Indians and corresponding texts were produced, conditions that did not become part of the Curtis's published work.

Duane Niatum, a poet and teacher at Western Washington University in Bellingham, as well as consultant on American Indian heritage, discusses the aesthetic dimension of Curtis's work. He describes the aims and aesthetic characteristics of the early artistic or pictorialist photographers as they relate to Curtis's development as an artistic photographer. Niatum emphasizes the importance pictorialists placed on careful selection of subject matter from nature, on harmonious composition, and on striving to convey a personal impression of the subject in the photographic image. He then gives sensitive readings of some of Curtis's best-known images of Plains Indians—his portraits of Red Cloud (plate 13), Hollow Horn Bear (plate 4), and Black Eagle (plate 61), as well as *Sioux Girl* (plate 12), *At the Water's Edge* (plate 73), and *Waiting in the Forest* (plate 24).

Historical Background

Edward S. Curtis was well aware of the drastic changes that his Indian subjects were undergoing during the time he photographed and studied them in the field, yet he sought in this work to capture the "traditional" Indian. His stated intention was to form "a comprehensive and permanent record of all the important tribes . . . that still retain to a considerable degree their primitive conditions and traditions."[2] He and many of his contemporaries believed strongly that all Indians were members of a "vanishing race" and admired what were perceived as their heroic qualities as "noble savages." Attentive though he and his assistants were to differences between the Plains Indians and other native peoples, Curtis could not help but be shaped in his photographic approach by these culturally ingrained perceptions, such as the sweeping generalization that all native peoples were one homogeneous culture. Others must have shared these perceptions, as he obtained major financial support from the ex-

tremely wealthy J. Pierpont Morgan and political support from President Theodore Roosevelt, as well as funds from other individuals. Both Curtis and his contemporaries also believed that the displacement of Indian peoples—their forced removal to reservations and eventual destruction of their traditional ways of life—was inevitable.

These convictions account in large part for the extraordinary sense of urgency and devotion that Curtis brought to this work. Other photographers of his era, such as Joseph K. Dixon, Roland K. Reed, and the team of Frank A. Rinehart and Adolph F. Muhr, also made ambitious attempts to photograph great numbers of American Indian peoples, but none could rival Curtis's achievement. Sandweiss elaborates on this point and places his undertaking in the context of similar ones that preceded it. The immense scope of the project, the artistry of his photography, and his incredible devotion to the undertaking impress most who know it.

Curtis was a master of the pictorial style, the dominant photographic mode of the late nineteenth and early twentieth centuries. Some of the main traits that distinguish pictorialism in photography, especially in relation to Curtis's work, are a strong interest in the picturesque, careful attention to pleasing composition, use of broadly defined forms and tonal areas, references to symbol and allegory, and signs of the artist's hand (for example, use of soft focus, blurring of forms, retouching).[3] In order to capture the appearances of "traditional" Indians and their ways of life, Curtis employed these technical and other means, such as posing figures and using props (including some clothing), to create the kinds of images and moods he desired. This approach admirably suited Curtis's objectives. He wished to create beautiful images that also informed the viewer selectively about the sitters. In order to achieve such results, he and his darkroom assistants created images that were often highly manipulated and were criticized by some as inauthentic.

Though Curtis professed and believed himself to be making straightforward visual records, he was creating photographs that were more far complex. The artistic effects produced by the images must be considered in conjunction with Curtis's words.[4] As Sandweiss, Gidley, and Niatum all demonstrate in their essays, Curtis's images can be read or understood in more than one way.

It is important also to realize that *The North American Indian* does not represent the work of Curtis alone. Gidley's essay greatly enlarges our understanding of this point. Though Curtis was unquestionably the leading spirit of the enterprise, it was a collaborative effort that required considerable help from a team of devoted, highly skilled, and sometimes changing assistants.[5] Their work in the darkroom, in compiling ethnological data in the field, and in writing and editing of the texts was critical to the project's successful completion.

Curtis's Work on the Plains Indians

Despite a common tendency to regard Plains Indians as archetypal of all American Indians, Curtis and his team labored to record the amazing diversity of these peoples. He photographed various Plains Indian tribal groups at different times during the many years that he worked on the project. Dating Curtis's images with certainty presents problems, as Gidley explains, because the date of a specific image merely indicates the copyright date given to it when it was first published, not the date the photograph was taken, which could well have been years earlier. The photogravures for the exhibition and this book have been selected from the six portfolios of Curtis's opus that treat primarily the following tribal groups: Teton Sioux, Yanktonai, and Assiniboines (portfolio 3, published in 1908); Apsarokes (Crows; portfolio 4, 1909); Mandans, Arikaras, and Atsinas (Gros Ventres; portfolio 5, 1909); Piegans and (Northern) Cheyennes, (portfolio 6, 1911); Sarsis (Sarcees), Crees, Blackfoot, and Bloods (portfolio 18, 1928); Wichitas, (Southern) Cheyennes, (Southern) Arapahos, Otoes, and Comanches (portfolio 19, 1930). The images and accompanying text thus fall into two chronological groupings, one ranging from approximately 1900 to 1910 and the other in the mid- to late 1920s.

The span of time that Curtis photographed and worked with Plains Indians also gives us an opportunity to consider whether his pictorial approach to photography changed appreciably over the course of the whole project. Curtis's portfolios and volumes of text on Plains Indians were published over more than twenty years, yet most exude a seemingly

timeless quality. Comparisons between some earlier and later images enable us to address this observation and highlight similarities and differences among major Plains Indian peoples.

The photogravures reproduced in this volume, like those in the whole of *The North American Indian*, are mainly portraits, as well as some landscapes and scenes of everyday life. The former portray individuals who range from the notable to the obscure and encompass members of highly varied societies dwelling within a vast geographical area. They include tribal groups or nations of the central plains such as the Oglala and Brulé Sioux, their traditional enemies the Apsarokes (Crows), northern plains members of the Blackfoot Confederacy (Piegans, Bloods, Blackfoot), and Canadian plains peoples such as the Crees and Sarcees. At the southern extreme, those residing in the plains of Oklahoma, formerly Indian Territory, include the Wichitas and Comanches, as well as many other tribes such as the (Southern) Cheyennes, (Southern) Arapahos, Otoes, Quapaws, and others for whom the southern plains is a "homeland" imposed upon them by the federal government comparatively recently in their histories.

The portraits include memorable images of celebrated chiefs such as Red Cloud (plate 13) and Plenty Coups (plate 26), along with others of striking appearance, such as *Makoyepuk ("Wolf Child")—Blood* (plate 37) and an unnamed *Sioux Girl* (plate 12) in gorgeous traditional dress. Little or nothing appears to be known about either of the latter. While Curtis typically takes great care to include details of dress that are culturally specific or are traditional to the tribe of the sitter, he also strives to respond to and capture something of each sitter's individuality.

A comparison between an earlier portrait of Plenty Coups, 1908 (plate 26), the famous Crow chief, and one of Old Eagle (Otoe), 1927 (plate 8), underlines the main traits of Curtis's portraits. Both, as is the case with many of Curtis's sitters, are carefully posed against a dark muslin backdrop in his studio tent. The photographer shows Plenty Coups fully frontal, bust length, in "traditional" dress and hairstyle with forelock curled upward, a fashion favored by Crow men. In true pictorial manner, Curtis employs selective use of light and focus, illuminating his subject from the upper left, which casts the lower right of his face in soft shadow. However, details, such as the beadwork on his animal skin shirt, the

many necklaces, and his braids, remain clearly visible. Splendidly attired, the Crow chief regards us with an unswerving gaze. The extended caption refers us to a biographical sketch of the sitter, which stresses his heroic actions, also reinforced by his name.

Nearly twenty years later, in the portrait of Old Eagle, Curtis employs more evenly distributed illumination than in the earlier portrait. Cropping the top of the image drastically, the photographer presents the Otoe chief in a frontal closeup, seen at a slightly upward angle. He makes less use of the soft focus seen in earlier images and captures clearly Old Eagle's bear-claw necklace, beaded necklaces, and medal bearing the portrait of President Abraham Lincoln. Instead of a biographical sketch, the photographer's extended caption informs us that the cylindrical headdress made of animal fur is characteristic of the older traditional style, unlike that seen in portraits of other Otoes made at the same time. Old Eagle regards the viewer gravely yet steadily, presented as a stalwart guardian of his people's native traditions. Though somewhat less pictorial in manner, the later portrait and its text, like the earlier image and text, both emphasize the idea of maintaining tradition. Plenty Coups and Old Eagle, though separated widely by time, distance, and history, are each portrayed in culturally specific costumes, and both appear caught in a similarly timeless realm.

Curtis's landscape views capture the distinctive character of indigenous plains peoples' varied homelands. When he began his project, all of the Indians whom he photographed were living on reservations. Even so, the geographic scope and variety of topography seen within the plains portfolios reflect physical environments traditionally inhabited by these peoples that differ from one another more markedly than perhaps expected. Consider, for example, the contrast between the treeless, vast, gently undulating grasslands of *An Oasis in the Bad Lands*, 1905 (plate 90) and the lush river encampment of the Crow seen in *On the Little Bighorn—Apsaroke*, 1908 (plate 15). Similarly, the arid background of the southern plains in *As It Was in the Old Days*, 1927 (plate 91), makes a striking juxtaposition to the lake environment of the Crees in *A Cree Canoe on Lac Les Isles*, 1926 (plate 3).

In addition to recording straightforward differences in terrain, Curtis's pictorial approach to landscapes also reinforces underlying themes of

timelessness and harmony in his work. For example, a closer look at *On the Little Bighorn—Apsaroke*, 1908, with its encampment reveals these themes. The composition reminds us of how a Euro-American artist like Albert Bierstadt might have depicted such a scene. Curtis surveys the scene from a prospect, frames the view with trees, and balances masses of light and dark so that the cluster of tipis stands out beautifully in the distance beyond the bend in the river. To enhance the picturesque effect, a wagon has been removed from left of center.[6] We behold a vision of Plains Indians living in harmony with nature. The serene vista exemplifies a characteristically pictorial emphasis on the picturesque. The caption places this scene a short distance below the Custer battle site. This brief allusion to Plains Indians' bravery is a theme in keeping with the overall tone of the scene, which pictures an idealized, timeless realm in which traditional ways of life appear intact and unchanged.

The balanced and self-contained quality of this view contrasts with *A Sarsi Camp*, 1926 (plate 34), in Canada. Irregularly patched tipis, pieces of wood casually heaped or scattered, and figures who appear randomly placed give this camp a much less picturesque appearance and illustrate a gradual waning of the pictorial aesthetic in Curtis's work. The earlier scene's caption refers to past victory in war. In contrast, this picture's extended caption places the band of Sarcees at a riverside grove near Okotoks, Alberta, awaiting improved weather so they can begin shocking wheat for one of their Caucasian neighbors.[7] In this rather exceptional text, Curtis conveys information historically specific to the scene shown, fixing his subjects firmly in the twentieth century and acknowledging, even if only briefly, its less than romantic economic realities.

Curtis's images also provide valuable records of Plains Indians' varied kinds of housing. These consist of tipis of plain or painted skin and muslin (plate 82), the grass houses of the Wichitas (plate 7), and the earth lodges made by upper Missouri peoples such as the Arikaras. All are carefully photographed and accompanied by detailed written descriptions. Curtis also alludes to ceremonial uses of these structures in texts (see *Arikara Medicine Fraternity*, 1908, plate 1, and *Lodge of the Horn Society—Blood*, 1926, plate 18) and sometimes gives glimpses of ceremonies practiced or reenacted near lodges. With the exception of *A Sarsi Camp* noted above, comparisons between earlier and later images of the main genres

reinforce the more important features of Curtis's photographic approach, including the "timeless quality" so typical of his work. These examples also underline how critical it is to consider the artistic effects produced by the images in conjunction with Curtis's words.

Reenactments and Reconstructions

In Gidley's essay in this volume, as well as in his recent book *Edward S. Curtis and the North American Indian, Incorporated,* he discusses the ways in which Curtis's photographs are "reconstructions, or more accurately, *constructions* produced at the behest of a prevailing ideology."[8] The term "reconstruction" as used by Gidley, and the related phenomenon of re-enactment, prove useful in considering Curtis's plains work.

Several images in this book record or relate to the reenactment of the Arikara medicine ceremony (plates 1, 32, 51). Curtis's caption for the group portrait *Arikara Medicine Fraternity,* 1908 (plate 1), documents the event: "In this group are shown the principal participants in reenactment of the Arikara medicine ceremony, which was given for the author's observation and study in July, 1908."[9] *Arikara Medicine Fraternity—The Ducks,* 1908 (plate 32), one part of the reenactment, presents a striking view of three fraternity members painted with ducklike markings and holding rushes, dancing around the sacred cedar. We do not know precisely on what terms the Arikaras agreed to allow Curtis to photograph their sacred proceedings. Like other photographers of his time, Curtis paid fees to Indians whom he photographed. It would be interesting to know more about the specific conditions surrounding the photography of this reenactment.

Gidley identifies *Ogalala War Party,* 1907 (plate 67), as an example of a reconstruction. In this image the Indians are a force to be reckoned with, yet when Curtis photographed them, the Plains Indian Wars had ended and they were restricted on reservations.[10] He also observes in his essay that sequences of pictures in Curtis's plains volumes present war-party activity despite the fact that war has ceased to be a possibility for the Plains Indians. He cites *The Scout's Report,* 1908 (plate 2), as an example; another one is *In the Black Cañon—Apsaroke,* 1905 (plate 28).

One of Curtis's best-known pictures, *The Three Chiefs—Piegan,* 1900

(plate 33), identified as a reconstruction, has much in common with the others mentioned. In this picturesque composition, he presents traditionally dressed Plains Indians (identified as Four Horns, Small Leggings, and Mountain Chief) on horseback as they pause before the moody backdrop of the prairie.[11] Curtis's caption reads: "Three proud old leaders of their people. A picture of the primal upland prairies and limpid streams. A glimpse of the life and conditions which are on the verge of extinction."[12] Though he clearly describes the homeland of the Piegans, he also intentionally omits any acknowledgment that the old ancestral way of life had already become extinct. This and similarly pictorial compositions evoke the Plains Indians' past freedom within the vastness of nature, yet they belie the very limited range of movement permitted these people.

In the Black Cañon—Apsaroke, 1905 (plate 28), elicits a similar response. Curtis's caption locates the scene in the Bighorn Mountains in Montana, an area traditionally favored by the Crows, and details the "Apsaroke custom of wearing at the back of the head a band from which fall numerous strands of false hair ornamented with pellets of bright colored gum."[13] Curtis thus imaginatively reconstructs for the viewer part of the Crows' traditional way of life, through image and word. We the viewers, however, know that these figures are essentially being memorialized. The Crows, like the Sioux and Piegans, were confined to reservation life at the time they were photographed. One cannot help but wonder who these individuals were. What was their understanding of their roles in the scene? On what terms did they take part? What role, if any, did Curtis's main Crow informant, A. B. Upshaw, have in making arrangements for this scene? These questions relate to those posed and discussed by Sandweiss, Gidley, and Niatum about Curtis's imagery. While their essays cannot completely answer these questions, collectively they illuminate possible new ways of looking at the photographs with greater appreciation for their complex nature.

Given the many challenges and difficulties in contacting and persuading Plains Indian peoples to be photographed and interviewed, the range of Curtis's visual records of them is extraordinary and provides what was, for his era, unprecedented recognition of their diversity. In

some instances, he photographed plains peoples for whom few other visual records exist. When we consider these pictures with their captions or other corresponding texts, we discover that Curtis did not create the straightforward visual documents that he intended. However romanticized, reenacted, or reconstructed his record, the comprehensiveness and arresting artistic quality of his photography of Plains Indians render them precious. I hope that the compelling character of the images themselves and the essays in this book will stimulate new examinations and new questions about the photographs and perhaps uncover stories formerly untold.

Notes

1. Photogravure refers to a process by which a photographic image is reproduced in printer's ink; it also designates a print made according to this procedure. In a series of complex steps, the image from a negative is transferred and adhered to a copper plate that is etched with ferric acid. The surface of the etched plate can then be inked and prints made in an etching press. Beaumont Newhall, *The History of Photography: From 1839 to the Present*, rev. ed. (New York: The Museum of Modern Art/New York Graphic Society, 1982), 142.

2. Edward S. Curtis, *The North American Indian*, ed. Frederick Webb Hodge (Cambridge MA: University Press, 1907), 1:xiii.

3. Michael Flecky, "Pictorialism," in *The Focal Encyclopedia of Photography*, 3d ed., ed. Leslie Stroebel and Richard Zakia (Boston: Focal Press, 1993), 633.

4. These include the extended captions he wrote for the photogravures in the lists of plates accompanying each portfolio, the biographical sketches, and other relevant statements in his texts.

5. Some of the most important of Curtis's skilled assistants were accomplished photographer Adolph F. Muhr, skilled linguist and self-educated ethnologist William E. Myers (later replaced by Stewart C. Eastwood), and A. B. Upshaw (Crow). Frederick Webb Hodge of the Bureau of American Ethnology edited the text.

6. Christopher M. Lyman, *The Vanishing Race and Other Illusions* (New York: Pantheon Books in association with the Smithsonian Institution Press, 1982), 71.

7. Curtis, *North American Indian* (Norwood MA: Plimpton Press, 1928), portfolio 18, list of plates, 620.

8. Mick Gidley, *Edward S. Curtis and the North American Indian, Incorporated*, (Cambridge UK: Cambridge Univ. Press, 1998), 70.

9. Curtis, *North American Indian*, portfolio 5, list of plates, 157.

10. Gidley, *Curtis and the North American Indian*, 278.

11. Tom Beck, *The Art of Edward S. Curtis: Photographs from the North American Indian* (Edison NJ: Chartwell Books, 1995), 30.

12. Curtis, *North American Indian*, portfolio 6, list of plates, 209.

13. Curtis, *North American Indian*, portfolio 4, list of plates, 136.

Picturing Indians
Curtis in Context

Martha A. Sandweiss

Casting himself as the Herodotus of a dying race, Edward Curtis roamed across western North America for more than thirty years, from the mid-1890s through the late 1920s, systematically documenting what he perceived as the vanishing cultures of the continent's native peoples. He was a voracious collector and recorder of legends and songs, linguistic practices, religious customs, foodways, and material culture. With a shifting crew of assistants, informants, and translators, he filled notebooks with data, pioneered the use of wax-cylinder recording techniques, experimented with motion picture film, and of course, made photographs. He produced tens of thousands of images, some 2,233 of which appear as lavishly produced photogravures in his monumental work *The North American Indian*, a set of twenty illustrated text volumes and twenty large-format portfolios published between 1907 and 1930. With expanded captions for his portfolio pictures and more complex literary narratives for his text illustrations, Curtis marries images and words to create seamless literary and visual records of native life from the southwestern deserts to the Alaskan north. The pictures make vivid the anthropological text but simultaneously draw much of their commu-

nicative power and ideological meaning from the words they illustrate. In *The North American Indian*, image and text are inseparable.[1]

The far-reaching scope of Curtis's work, the exceptional quantity and quality of his pictures, and the sheer length of his career set him apart from any other anthropologist or artist ever to work with Native American communities. Nonetheless, the overall concept of his work is not unique. Curtis worked within two established traditions—one an ideological tradition that helped shape the content of his pictures, the other a commercial tradition that helped shape how that content would be communicated and marketed to a public audience.

With *The Vanishing Race—Navaho*, the first image in his first portfolio (1907), Curtis allies himself with other proponents of the vanishing-race ideology so prevalent in mid- and late-nineteenth-century America. "The thought which this picture is meant to convey," he writes, "is that the Indians as a race, already shorn of their tribal strength and stripped of their primitive dress, are passing into the darkness of an unknown future. Feeling that the picture expresses so much of the thought that inspired the entire work, the author has chosen it as the first of the series."[2] Curtis's concerns about impending loss echo the anxieties of his artist-predecessors—both painters and photographers—who had likewise set out to document the cultures of America's native people. Writing in 1841, the painter George Catlin explained that his visual records of Indian life were intended to snatch "from a hasty oblivion what could be saved for the benefit of posterity."[3] In 1858, Washington DC studio photographer James E. McClees similarly predicted the lasting importance of his collection of Indian delegation portraits "as momentoes of the race of red men, now rapidly fading away."[4]

The premise of the vanishing-race ideology was that traditional Indian cultures and peoples would inevitably disappear because they were incapable of adapting to changing political and material circumstances. To craft visual documents that would support such a belief, artists depicting a vanishing race tended to ignore or minimize evidence of successful cultural adaptation, sometimes inventing a visual record even as they purported to document actual practices. Through artful arrangement of his subjects and the equally artful exclusion of some of their surroundings, Curtis often presented an illusory image of contemporary Indian

life that denied the cultural complexities of the historical present. In ignoring the trains that crisscrossed the northern plains or the oil wells that dotted the Oklahoma hills, he followed in a long tradition of both painters and photographers who had likewise sought out the seemingly "pure" and unchanging aspects of Plains Indian life earlier in the nineteenth century.[5]

And he had good company in his own era. No one looking at the turn-of-the-century Sioux portraits made by photographer Gertrude Käsebier would suspect that the sensitive, romantic photographs depicted members of Buffalo Bill's Wild West show then performing in New York City.[6] Curtis's contemporary and sometime rival Joseph Dixon even bragged in 1909 that in his own pictures "of Indian life, every effort was exhausted to eliminate any hint of the white man's foot."[7]

But even as Curtis's *North American Indian Portfolio* represents an extravagant culmination of the vanishing-race aesthetic, its physical and conceptual presentation also evokes an even more fundamental tradition in the history of photographic representations of American Indians, a tradition of marketing Indian images as public and didactic photographs. This commercial tradition incorporates several broad assumptions about photographs of Indian peoples: the pictures could convey complex cultural and historical ideas, particularly when amplified with descriptive captions; the pictures could have a market appeal; and finally, the ultimate consumers of these views would not be the sitters themselves. This last point is important. The overwhelming majority of photographs made in the United States during the nineteenth century were portraits. And the overwhelming number of these portraits were made for the sitters themselves, for deeply private purposes. The sitter who possesses his or her own photograph can maintain some control over the uses and interpretations of that image. But when a portrait enters a more public realm, this kind of control disappears, as photographers, publishers, and viewers themselves affix their own explanatory words to a picture. "Brother Jack" might become "Anonymous '49er"; a favorite uncle a generic member of a "vanishing race." The publication of images transforms private moments into public spectacles, personal pictures into commodities, records of specific events into free-floating visual metaphors.

There were, during the nineteenth century, essentially two kinds of photographs: private images, made for, paid for, and used by particular individuals, and public images, made for speculative purposes and designed to be marketed and sold to an audience of curious consumers. Curtis's pictures are emphatically public photographs, intended to communicate his agenda, not those of his sitters.

Public photographs might come to the marketplace in many different forms—as stereographs, cabinet cards, large exhibition prints, and later as postcards—but one of the things that generally marks them as public images is words. They might appear with words scrawled across the face of the image, with titles printed along the sides of the mounts, with brief narratives printed on the backs of the cards on which the pictures were mounted, or with captions or texts in a descriptive pamphlet. With words, photographers could reinforce one reading of the image at the expense of others, erasing the multiple possibilities and ambiguities inherent in any unlabeled print. Such is certainly the case with Curtis's work. Consider, for example, two of the images in Curtis's portfolio volume 3 on the Lakota tribes—*High Hawk* (plate 6) and *Prayer to the Mystery* (plate 10). While the images themselves depict subjects Curtis encountered in the first decade of this century, the accompanying captions evoke a more distant past, underscoring Curtis's central belief that the true glory days of the tribe were over. Transforming High Hawk into the living voice of a disappearing race, Curtis explains that he is "prominent among the Brules mainly because he is now their leading historical authority, being much in demand to determine the dates of events important to his fellow tribesmen." Clarifying the importance of the buffalo skull in the "prayer" image, Curtis notes that it is "symbolic of the spirit of the animal upon which the Indians were so dependent."[8] Bounded by words, his pictures acquire narrative import as images of a fading past.

Before the 1890s, when the introduction of the easy-to-use Kodak camera and the expansion of tourism brought countless amateur photographers to the West, most photographs of Plains Indians—like Curtis's later pictures—were published with literary captions and marketed as parts of narrative series that either implicitly or explicitly laid out the case for the diminishment of native cultures. They thus provide a visual counterpoint to the most deeply ingrained story of nineteenth-century

western art—the progress of the American nation, celebrated in count-
less paintings and photographs of railroad construction, mining, and
America's growing western metropolises. The photographs made by the
operators working for railroad magnates, government survey teams, or
ambitious land developers almost invariably functioned as forward-
looking documents of westward expansion, predicting and celebrating
the day when the West would be fully integrated into the nation's ex-
panding economic and political order.[9] These celebratory images and
the photographic images predictive of the Indians' future worked to-
gether to convey a single image of the nation's destiny. As America grew,
Indian communities would disappear; as American technology spread
westward, native ways of life would fade into oblivion. The two stories
of historical change—one illustrating an upward trajectory of progress,
the other a downward spiral of decline—were twinned. One made pos-
sible, set into motion, and clarified the moral meaning of the other.

The public presentation of Plains Indian images has its roots in the
pre–photographic era of the 1820s and 1830s when both government
agents and independent entrepreneurs began to produce visual records
of plains life for factual as well as remunerary purposes. In 1821 Thomas
McKenney, the government's Commissioner of Indian Affairs, began
collecting painted portraits of Indian leaders for an educational "Indian
Gallery" that would offer a lasting visual record of the peoples he be-
lieved were doomed to disappear. He commissioned the Washington DC
painter Charles Bird King to make oil portraits of the tribal delegates
who traveled to the nation's capital to conduct business with the federal
government. And from the Philadelphia-based artist James Otto Lewis,
he purchased watercolor field sketches of various midwestern treaty gath-
erings for King to later copy in oil for the gallery. Searching for a wider
audience, McKenney resolved to use the pictures as the basis for an illus-
trated Indian history. Overcoming numerous political and financial ob-
stacles after losing his government post in 1830, he eventually published,
between 1836 and 1841, a lavish three-part portfolio of lithographic re-
productions of the paintings.[10] McKenney's collaborator, the Cincinnati
jurist and writer James Hall, wrote a historical text for the large-format
History of the Indian Tribes of North America, which directed readers' un-
derstanding of each individual image with biographical sketches that

elucidated the sitter's tribal history and personal character. The text transformed the pictures into instructive images, informing readers that the Sauk chief Keokuk, for example, was "a magnificent savage. Bold, enterprising, and impulsive, he is also politic, and possesses an intimate knowledge of human nature." On the other hand, of the Sauk leader "Pashepahaw, the Stabber" there could "be no question that the agreeable epithet by which he has chosen to be distinguished, is indicative of his character."[11]

The painter George Catlin, an artist whose single-minded devotion to the visual documentation of America's Indian tribes makes him a kind of prephotographic prototype for Edward Curtis, made a number of painting expeditions through the Midwest and across the northern and southern plains in the 1830s.[12] Unlike other itinerant painters of the time, who traveled from town to town making and selling portraits to private clients, Catlin sought images for himself, amassing materials for the elaborate "Indian Gallery" of images and artifacts with which he planned to educate east coast audiences. By the fall of 1837, Catlin's Indian Gallery was on view in New York City, where night after night Catlin himself explained to curious viewers the rich complexities of Indian cultures. Bitterly disappointed that the government would not purchase his collection of paintings, Catlin took his gallery to Europe, hoping foreign audiences would better appreciate his work. His presentation became increasingly theatrical—first with white men garbed as Indians and later with Ojibwe and Iowa Indians he imported from America—but his spirited lectures remained central to viewers' understanding of his paintings. In his theatrical presentations, as in his illustrated publications, he used words to clarify the romance of Indian life and the impending disappearance of native cultures. His paintings seemed to offer some sort of information, but he needed language to elucidate their portentous meanings. Only with words, for example, could Catlin convey that the celebrated Mandan chief Four Bears, whom he painted on the Upper Missouri in 1832, was "the most extraordinary man, perhaps, who lives at this day, in the atmosphere of Nature's noblemen." Searching for classical metaphors to give his story heroic weight (and not coincidentally to underscore his own role in the drama), Catlin noted, "No tragedian ever trod the stage, nor gladiator ever entered the Roman Forum, with more grace and manly

dignity than did Mah-to-toh-pa enter the wigwam, where I stood in readiness to receive him."[13]

By the 1840s and 1850s, then, as the first photographers began to venture, however tentatively, into the plains, there was an established tradition for the publication and exhibition of Indian portraits and genre scenes drawn from life. The tradition embraced pictures and words as twinned modes of descriptive explication, regarded Indian images as part of a bigger story about American expansionism, and relied on a paying eastern audience as the chief market for western views. But daguerreotypy, the first practical and widespread kind of photography practiced in this country, was ill-suited to producing images that could reach an audience in such a familiar way. Daguerreotypes are small images on highly reflective sheets of silver-plated copper, and they are inherently difficult to display or even to view. Though in rare instances they might be mounted on a wall, they were almost always made to be held in the hand and looked at in a private, even intimate, sort of way. It is difficult for more than one person at a time to see a daguerrean image, hard to affix more than a short paper title to a daguerrean plate or case, and hard even to redraw a daguerreotype for a printed reproduction. Moreover, daguerreotypes are unique images, made without negatives, and so are hard to mass produce. For all these reasons, the early daguerreotypes of indigenous peoples did not fit easily into the kind of public, narrative format for the presentation of Indian images that had been established by men such as McKenney and Hall or Catlin. But with the advent of the new wet-plate negative technology in the 1850s, it became possible to produce photographs that could more easily move into the public marketplace. With the new technology, photographers could produce glass negatives from which they could make any number of prints on paper. Unlike daguerreotypes, these paper prints could easily be exhibited, married with descriptive language, and used to convey stories.

The first photographer to market a set of paper images of the interior West—a set that included a number of images of plains tribes—was the well-known painter Albert Bierstadt, who in 1860 offered for sale fifty-two stereoscopic *Views in the Far West*. Bierstadt had made the views during the spring and summer of 1859 when he traveled west, at his own expense, with Frederick West Lander, a government engineer leading a

surveying expedition west from South Pass to California. Bierstadt accompanied Lander's party along the Platte River in Nebraska as far as Fort Laramie and the Wind River Mountains of Wyoming. He returned home in September with a collection of sketches and more than fifty wet-plate stereoscopic negatives that he turned over to his brothers Charles and Edward for publication. The fifty-one western stereo views in the Bierstadt Brothers' 1860 catalogue included eighteen views of "Oglallahs" (Oglalas), Cheyennes, Shoshones, and other Indian peoples and their villages.[14] "We have a great many Indian Subjects," Bierstadt wrote. "We were quite fortunate in getting them, the natives not being very willing to have the brass tube of the camera pointed at them. Of course they were astonished when we showed them pictures they did not sit for; and the best we have taken have been obtained without the knowledge of the parties, which is, in fact, the best way to take any portrait."[15]

In the Bierstadt Brothers' pamphlet, Albert's *Views in the Far West* are sequentially numbered and listed with brief titles. Although the listing neither traces the westward progress of the expedition nor groups views of like subjects, the Indian images acquire a particular meaning within the logic of the list. While some photographs document the process of westward migration, show the ease with which rivers can be crossed, and picture landmarks along the way, others depict the Indians as exotic but safe peoples who would present little impediment to the westward flow of American people, merchandise, and political government. These first Plains Indian portraits to be widely marketed thus proved predictive of how countless others would be published and sold during the nineteenth century. From the start they were marketed as part of a broader cultural and political story about westward migration.

The earliest published reproductions of a series of Plains Indian photographs tell a similar tale. The pictures appear in Ferdinand Vandiveer Hayden's essay "Contributions to the Ethnography and Philology of the Indian Tribes of the Missouri Valley," published in the *Transactions of the American Philosophical Society* in 1863, some three years after the appearance of the Bierstadt catalogue. During the mid-1850s Hayden made two trips to the Upper Missouri, one under the auspices of the American Fur Company, the other with a military exploring party. A geologist by training, Hayden returned to the West in 1859 with Capt. William F.

Raynolds's exploring expedition to the Yellowstone and Upper Missouri Rivers. Also along on the expedition was James D. Hutton, a photographer of indifferent talent, who made pictures of the river topography as well as a handful of portraits of the Crow and Arapaho people who had served as linguistic informants for the Americans. When Hayden published his ethnographic report on the Upper Missouri tribes a few years later, he included lithographic reproductions of seven of these early field portraits. In his explanatory note he clarifies that the most valuable Indians were those who cooperated with whites and exhibited seemingly non-Indian behaviors. A "Shyenne brave" who provided linguistic assistance possessed "fine natural powers, quick perceptions and intelligence, increased by long association with the white." The Dakota medicine man Iron Horn was "a warm friend of the whites and has done much to harmonize difficulties among his people." The Yankton chief Smutty Bear managed "the affairs of his people with ability and prudence."[16] Such characterizations, though ostensibly favorable, met the needs of the publisher and the imagined needs of the consumer rather than the needs of the sitters themselves. In this case, they serve to reconfirm the value and accuracy of the linguistic information provided by these men and simultaneously neutralize any perceived threats or dangers they might pose. Hayden's words are critical to shaping the meanings these images had when they came to public attention. While the portraits alone might suggest any number of possible readings, the words restrict and clarify their meanings, at least as Hayden wanted them to be understood. The intentions, needs, and ambitions of the sitters are nowhere to be found. In the public marketplace of viewers, Hayden's needs win out.

Over the coming decades, the message put forth by photographers of Plains Indians was refined but changed little in its general message. The Indians existed as a foil, a backdrop, for the inevitable Americanization of the West. Though a single photograph alone might not be able to convey this message, photographs arranged in series and explicated with words could convey such a story to the buying public.

The Omaha photographers Mitchell and McGowan, active in the mid-1870s, marketed their stereoscopic views of Sioux, Arapaho, and Cheyenne subjects in several series. Each image bore the titles of all the pictures in the group on the back of its mount. This was a common prac-

tice that not only saved the photographer money (by providing him with a printed mount he could use for a great many images) but gave the buyer a sense of how one image fit into an organized sequence of views. The *Indian Chiefs Portrait Series* presented a group of tribal leaders in collectible form, and in its emphasis on military leaders—rather than women, children, or domestic genre scenes—subtly conveyed the idea of Indians as threatening military foes. But the companion series *Military Posts and Indian Views* conveyed the bigger story. The Plains Indians existed within the political and military context framed by American forts, outclassed by the superior technology and political power the military outposts represented. The chiefs featured in the other series of views were implicitly contained and rendered powerless by the framework in which they lived.[17]

The Yankton, Dakota Territory, photographer Stanley J. Morrow likewise tipped his hand in the mere organization of his stereoscopic views of northern plains life. His sets of views of *Custer's Battlefield* and *Crook's Expedition against Sitting Bull 1876* related the story of the military conquest of the plains, and a set of views identified as *Local Series, Yankton* carefully documented the growing commercial prosperity of Yankton's downtown commercial district. But his *Indian Series* of eighty-three stereographs, mainly of Sioux, Cheyenne, Bannock, and Crow subjects, was set apart as a kind of separate story. It was as if Indians existed outside of history, outside the story of military actions or urban growth. The trajectory of change for white settlers might lead ineluctably upward. But for Indians, change could move only in the opposite direction.[18]

A. J. Russell, the photographer who documented the construction of the Union Pacific Railroad "across the continent west from Omaha," issued at least fifteen series of stereographic views, including hundreds of images of railroad construction, topography, and notable sites along the route, which celebrate America's technological conquest of the West. But his Indians were all grouped together in series fifteen, randomly arranged among views of settlers and early western tourists. Again the message is implicitly clear: the Indians are irrelevant, at best picturesque, and no impediment to the westward flow of American civilization.[19]

When the lecturer S. J. Sedgwick incorporated Russell's images into his own illuminated slide productions, he made the point in an even

more direct way. Wedged between views of Sacramento and San Francisco and equally glorious views of the sublime wonders of the Big Trees, Yosemite, and Yellowstone was a group of pictures entitled *Indians, Mormons and Old Missions*, images representing three cultural groups whose distinctive beliefs and practices made them increasingly irrelevant to the new American political order.[20]

Stereographs like these were generally marketed with brief descriptive titles affixed to the front and were often mounted on cards that included on the back a complete list of titles in a particular series of views. The somewhat larger images published in the cabinet card format, however, might be marketed with more complete biographical information on the back of the card mount. Zalmon Gilbert, a photographer active in Mandan, Dakota Territory, in the 1880s and 1890s, used such printed biographies to create a kind of elided history of Upper Missouri Indian life that focused on the Indians' cooperation with whites. Running Antelope, for example, "Has always been a friendly Indian. . . . On several occasions he has been instrumental in saving the lives of white men, and was very much liked by the old settlers." Gray Bear "was a scout in General Terry's command. He was always considered a good scout and friend of the whites." Big John, "a famous man among the Rees and Upper Missouri Indians . . . has been a scout in the employ of the government for twenty years, and holds twenty 'good' government discharges."[21]

This emphasis on "good" Indians represents technical imperatives as well as cultural beliefs and marketing strategies. Though a Saint Louis newspaperman might note with forced jocularity in 1878 that a series of Indian views made by the Sioux City, Iowa, photographer J. H. Hamilton "are quite refreshing from this standpoint, when we know there is no danger of losing our scalp," few photographers ever put themselves in true danger to make their Indian portraits.[22] The slow, laborious process of making and exposing the wet-plate negatives still in use in the early 1880s made it all but impossible to make photographs under anything other than carefully controlled and orchestrated circumstances. It was difficult to capture action, hard to make a portrait of anyone who wasn't knowingly collaborating with the photographer. Painters might invent lurid scenes that appealed to popularly held ideas about the threats posed by native peoples. But although photographers could create or orches-

trate views of violent Indian behavior, their efforts inevitably looked foolish and had none of the emotional resonance of some of the earlier paintings. For photographers it was easier to render the Indians exotic, archaic, or even friendly rather than threatening and violent. Such characterizations partly reflect changing perceptions in the mid–nineteenth century, as the vanishing-race trope became increasingly prevalent from midcentury on, but they also betray the limitations of the camera. Photographers who wanted to depict native subjects as hostile or dangerous generally had to resort to words to impute such meanings to their pictures.

The biggest publisher of Indian pictures during the nineteenth century was probably the federal government. In 1858 the Washington DC photographers Julian Vannerson and Samuel Cohner, both in the employ of the James E. McClees Studio, made a systematic effort to photograph the ninety delegates from some thirteen tribes who were in the nation's capital to engage in treaty negotiations. The following year, the Smithsonian Institution's first secretary, Joseph Henry, proposed that the government take on a photographic documentation project of its own. His words went unheeded until 1865, when a terrible fire destroyed the Smithsonian's art collection, one that included most of the delegation paintings that Charles Bird King had made for Thomas McKenney some four decades before. Henry then suggested it was time "to begin anew . . . a far more authentic and trustworthy collection of likenesses of the principal tribes of the US. The negatives of these might be preserved and copies supplied at cost to any who might desire them." Although Henry failed to secure government funding for a grand project, contributions from photographers and private philanthropists resulted in a collection of Indian portraits on deposit at the Smithsonian by the late 1860s.[23]

In 1869 Washington photographer A. Zeno Shindler produced for the Smithsonian a catalogue of 301 of these images entitled *Photographic Portraits of North American Indians in the Gallery of the Smithsonian Institution*. The listings provide simple, bare-boned information—a catalogue number, the transliteration of an Indian name, an English translation of that name, a tribal identification (often with an indication of the subject's status as warrior, chief, or headman), and a general indication of the geographical area in which the subject resided. With just a few excep-

tions, all of the subjects were males and a disproportionate number were chiefs, not surprising since many of the portraits depicted the delegates sent to Washington DC on behalf of their tribes.[24]

Only a few of the catalogue entries have biographical or anecdotal information appended to these spare identifications. But these skeletal narratives nonetheless help to construct a public meaning and moral for the entire collection of photographs. Those who merit amplification are largely the "good" Indians, whose actions on behalf of whites or whose own mixed-blood status mark them as assimilating ethnics who reaffirm the necessity and logic of Americans' vision of a non-Indian future. Thus the catalogue writers single out for special attention two Indians who rescue a group of white women and children from "hostile Indians," a loyal guide who—despite grievous wounds inflicted by hostile Indians—led General Sibley's military expedition through the Badlands of Dakota Territory, and a wealthy Isleta Pueblo man who loaned money to the American government in New Mexico. Also noted are a few Choctaws of mixed European and Indian heritage. A handful of "bad" Indians likewise merit description, such as a leader of the Minnesota "massacre" of 1862. With words, Shindler imputes moral meanings to seemingly neutral photographs.

The far more elaborate *Descriptive Catalogue of Photographs of North American Indians* was prepared by photographer William Henry Jackson and published eight years later, in 1877, under the aegis of geologist Ferdinand V. Hayden's Geological Survey of the Territories. It incorporates most of the images from the Shindler catalogue but augments them to create a much more complex narrative about Native American life. The collection, Hayden claimed, now included over one thousand negatives "representing no less than twenty-five tribes" and was destined to have enormous historical value, for the "present" recorded in these photographs, made over a period of twenty-five years, was already the past. "Many of the Indians portrayed have meanwhile died," Hayden wrote. "Others, from various causes are not now accessible; the opportunity of securing many of the subjects, such as scenes and incidents, has of course passed away." And as much as these pictures documented a past, they also predicted the Indians' inevitable future. "The value of such a graphic record of the past increases year by year," Hayden explained, "and there

will remain no more trustworthy evidence of what the Indians have been than that afforded by these faithful sun-pictures."[25]

In explaining the construction of the catalogue, Jackson noted that "particular attention has been paid to proving the authenticity of the portraits of the various individuals represented," that physical measurements of the subjects had been provided whenever possible, and that biographical and historical facts had been culled from published works, from the Indian delegates themselves, and by "correspondence with agents and others living in the Indian country." Revealing that these portraits were imagined as part of a comprehensive archive of knowledge, he noted that "all photographs are numbered upon their faces." Each had its place within the larger story.[26]

In the case of the plains tribes that are our focus here, that story was one of progressive civilization, the discarding of old ways in favor of the new. The Lakota peoples living on the Lower Missouri and in eastern Dakota Territory were, according to the catalogue, "nearly self-supporting. The Santees in Nebraska especially have entirely renounced their old form of life; have churches and sabbath-schools, which are regularly attended." They even had a monthly tribal newspaper. The Omahas were successfully turning to agriculture and had three good schools. Their "older Indians are also abandoning their old habits and assisting in building for themselves upon forty-acre allotments of their lands." The Osages were "making rapid progress toward a self-supporting condition." The Pawnees "have well-organized day and industrial schools, and are well-supplied with implements and means to carry forward a systematic cultivation of the soil."[27]

Things were a bit more problematic on the northern plains, where on the Crow reservation, for example, "the best farming lands . . . are most exposed to these hostile incursions." Nonetheless, "a mile and a half of ditch, sufficient to irrigate several hundred acres, has been dug, and it is hoped that another season will see at least a beginning made toward the civilization of these 4,000 wild but always loyal Crows."[28]

While narratives such as these made broad, sweeping generalizations about the histories of the different tribes, shorter narratives explicated many of the individual portraits. These brief biographical sketches appeared both in the published catalogue and on the backs of the portraits

given away and sold by the government. When you purchased a portrait, you could turn it over and learn its meaning and significance. You could find out who was well spoken, who was well developed, who was well off. You could learn that the Mdewakanton leader Little Crow, who "had not only visited Washington, and was supposed to be friendly to the whites, but had promised to have his hair cut and become civilized," later led a group of Sioux against the whites in the so-called Minnesota massacre of 1862. His biographical sketch, which notes that he was killed after fleeing into Canada, thus transforms this portrait from one that could serve as a parable for civilizing progress to one that represents a cautionary tale of deceit and treachery.[29]

The stories that fill the Jackson catalogue are emphatically stories that serve the interests of the federal government. They would seem to underscore the idea that nineteenth-century photographs of American Indians were inevitably the result of an inequitable power relationship between photographer and subject. Such, indeed, is the effect of the catalogue that inscribes moralistic meanings upon the portraits of many hundreds of Indian subjects. But to view the Indian subjects as hapless victims is to demean the agency, intelligence, and potential needs of the sitters. As the Comanche journalist and writer Paul Chaat Smith argues, "In this relationship we're portrayed as victims, dupes, losers and dummies. Lo, the poor fool posing for Edward Curtis wearing the Cheyenne headdress even though he's Navajo. Lo, those pathetic Indian extras in a thousand bad westerns. Don't they have any pride? I don't know, maybe they dug it. Maybe it was fun."[30]

Indeed, if one goes back to some of the very earliest records of encounters between Euro-American photographers and Native American subjects, that is precisely what one finds—evidence that Indian subjects were fully capable of comprehending the possibilities of the photographic medium. Consider one of the very earliest Indian-written accounts of posing for a daguerrean camera. The Ojibwe Kah-ge-ga-gah-bowh, also known as "George Copway, a Christianized Indian, and a chief of the Ojibway nation," published an account in 1851 of having had his picture made in Toronto a few years previous. After sitting for a daguerreotype portrait, he "viewed it with much curiosity" and took it back to his village, where he showed his friends the miniature seemingly "painted

by the sun." When his friends and family looked on uncomprehendingly at the unfamiliar object, Copway pronounced them "ignorant of the principles of this beautiful art" that he himself embraced as a marvel of both science and art.[31]

During the daguerrean era—that period before photographs were so easily transformed into public images for the marketplace—there is ample evidence to suggest that portraits of Indians were not always public pictures whose meanings were controlled by photographers or their publishers. Let us consider for a moment the stories of four of the earliest photographs made of the peoples indigenous to the present-day United States.

On 30 May 1843 Timoteo Ha'alilio, a young, high-ranking Hawaiian chief, paused from his diplomatic rounds in Paris to sit for his daguerreotype portrait. His companion, William Richards, noted in his journal, "Afternoon wandered around in search of a good portrait painter for Haalilio found none at leisure, had daguerotype [sic] likeness taken." Ha'alilio thus became the first native inhabitant of the present-day United States to be photographed. In his sixth-plate studio portrait he wears formal dress, presumably the diplomatic garb he customarily wore in Paris. A double row of shiny brass buttons marches down his dark coat and his hand rests on a book, a mark of his learning and intellect.[32]

In early June 1843, less than two weeks after Ha'alilio sat for his portrait in Paris, an unknown number of southern Plains Indians posed for their photographic portraits in Tahlequah, the center of the Cherokee Nation, in present-day Oklahoma. They were delegates to a large conference convened by Cherokee leader John Ross to forge new alliances between some of the tribes recently displaced by the federal government's policy of Indian removal. The portrait painter John Mix Stanley and his associate, Caleb Sumner Dickerman, who were there gathering portraits for a touring Indian Gallery of paintings and artifacts, had with them what was probably the first daguerreotype camera ever to appear on the southern plains. Impressed by the apparatus, Lewis Ross, brother of the Cherokee leader, invited Dickerman and Stanley to his home in July to make daguerreotype portraits of his family. Over a period of four days the artists made ten photographic portraits, none of which are known to survive.[33]

In late 1844 or early 1845, while on a lecture tour of Great Britain, Kahkewaquonaby, also known as the Reverend Peter Jones, also paused to have his photograph made. Jones was the son of a Welsh surveyor and an Ojibwe Indian woman who had been raised with his mother's tribe until his father removed him at the age of sixteen. Now a Methodist and a bilingual missionary among the Ojibwe, Chippewa, and Iroquois tribes, he posed at least twice for the great Scottish photographers David Octavius Hill and Robert Adamson, once in clerical garb, once in Ojibwe dress.[34]

The Sauk and Fox chief Keokuk and his associates, daguerreotyped by Thomas Easterly in Saint Louis in March 1847, were perhaps the first Native Americans to have their pictures made at a photographic studio within the United States. Traveling from their new reservation in present-day Kansas by Missouri River steamboat, Keokuk and his companions arrived in Saint Louis on 23 March, presumably to conduct official tribal business with the resident Indian agent. But while in the city the chief and "ten of his warriors" also performed a "war dance" with the Grand Olympia Circus, "superbly decorated in genuine Indian style."[35] His portrait is thus hard to read. Does Keokuk pose with his silver-tipped cane, bear-claw necklace, and peace medal because these accouterments were calculated to impress negotiators? Or was this his circus garb, donned to impress visitors paying to watch his "war dance"?[36]

Easterly, Stanley and Dickerman, Hill and Adamson, and the anonymous French daguerreotypist each had commercial reasons for making their portraits of native subjects. Easterly exhibited Indian portraits in his Saint Louis gallery; Stanley and Dickerman sought material for their touring show; Hill and Adamson (who rejected daguerreotypy in favor of an early paper negative process popular in Europe) made multiple copies from their negatives to sell; and the unnamed Frenchman would probably have welcomed a well-dressed foreign client with cash. But one should not imagine that their subjects did not also have uses for the pictures. Ha'alilio and Jones perhaps sought pictures they could use to advance their political or religious missions. Lewis Ross *invited* daguerreotypists to his home, an act that suggests he was behaving like any patron seeking pictures for his personal use. The existence of Easterly portraits both of Keokuk's son and of the older chief's wife together

with her grandson suggests the possibility that Keokuk might have bartered with Easterly. He would pose if he could have some family pictures to take home in return.[37] The exchange is prosaic. But it reminds us that native sitters—like any other photographic subjects—could have personal ambitions for a portrait sitting. Many later nineteenth-century photographs of Native Americans were indeed used to endorse a political agenda that involved a systematic attack on native cultures. Yet to see every photograph of an indigenous person as an act of cultural imperialism is to deny the ambitions of the sitter, as well as the cultural malleability of the photographic image.

The daguerrean era did not last long, and the switch to a glass-plate negative process in the late 1850s signaled a cultural shift as well as a technological change. The encounter between photographer and Indian subject became infused with greater commercial possibilities. Instead of a small and unique daguerrean view, photographers could now produce multiple copies of paper prints, and to sell these prints they had to find new ways to reach out to prospective buyers. The needs of the sitter became increasingly less important as photographers began to imagine the commercial utility and marketability of their pictures.

The vast majority of nineteenth-century Plains Indians photographs thus became public pictures that entered the marketplace promoting—in one way or another—an imperialist agenda of western settlement that denied the continued viability of native cultures. But there was nothing inherent in the photographic process itself that dictated this. Photographers might objectify their subjects or inscribe Eurocentric stories across the face of their prints, but their subjects were not necessarily silenced. When the Hunkpapa Sioux medicine man and war chief Sitting Bull signed a contract with Buffalo Bill's Wild West show in 1885, he demanded the exclusive right to sell souvenir photographs of himself and to charge a fee to patrons who wanted to pose with him for a tintype.[38] Invisibly (and in the case of his signed photographs, quite visibly), he thus inscribed every commercial picture of himself with a personal counternarrative that marked his own stake in the marketplace of images.

When the Apache leader Geronimo posed for Edward Curtis in 1905, he dressed the part of the "historical old Apache" Curtis needed for his

first volume of *The North American Indian* portfolio. Wrapped in a blanket, his wrinkles accentuated and facial details softened, Geronimo seems a relic of the past, a poster boy for the vanishing race. But like Sitting Bull, Geronimo was scarcely the hapless victim of photographic technologies. The year before posing for Curtis, he had traveled to the Saint Louis World's Fair where, he tells us, "I sold my photographs for twenty-five cents, and was allowed to keep ten cents of this for myself. I also wrote my name for ten, fifteen, or twenty-five cents, as the case might be, and kept all of that money. I often made as much as two dollars a day, and when I returned I had plenty of money—more than I had ever owned before."[39] The year after Curtis made his retrospective portrait, Geronimo—still in military custody—published his own "as-told-to" autobiography, blasting the military establishment and including photographs that seemed to illustrate the trajectory of his life. These photographic illustrations depicting Geronimo "dressed as in days of old" and garbed as if "ready for church" together contradict Curtis's image of him as a figure unable to adapt to changing times.[40] Geronimo instead comes across as a performer adept at playing multiple roles.

Such counterreadings of photographs come not just from subjects but also from viewers. In the early 1980s a group of Yankton Sioux people came together to reexamine some of the nineteenth-century portraits included in William Henry Jackson's 1877 government catalogue.[41] Jackson's compendium had included entries for thirty Yankton subjects. None had a biographical profile attached but all appeared within the context of Jackson's general remarks about the Yanktons and their associated tribal groups who had "made more substantial progress in civilization, many of them having permanently discarded their Indian habits and dress."[42] In the modern Yankton Sioux publication that resulted from this investigation, Jackson's images are infused with new life and new meanings, as the simple trajectory of progress he imagined is complicated by the recollections of the sitters' relatives who refuse to see these portraits as emblems of cultural disintegration.

Struck By the Ree, who appears in four photographs included in Jackson's collection, here has his own story as a peace-loving leader and gifted orator. Born in 1804 while Lewis and Clark were camped near a Yankton village on the upper Missouri, Struck By the Ree was wrapped

in an American flag shortly after birth amid predictions that he would become a great friend of the whites. But later in his life he had troubling and recurring visions of whites building new houses over ruins of Lakota homes and came to regret his earlier support of the 1858 treaty that had ceded away so much tribal land.[43]

Smutty Bear, who also appeared in the Jackson catalogue, appears here as an expert hunter especially skilled at self-camouflage who became a symbol of resistance to white policies. Feather in His Ear, his name more properly translated as Feather Necklace, is presented as an opponent of white missionaries who gained respect as one of the first to foresee the possibilities of religious and cultural oppression by the newly arrived Americans. We also meet Little White Swan, known for his intelligence, wit, and humor, and Walking Elk, still celebrated for his thirty-year fight to win government reparations for the Yankton scouts who in 1864 helped federal authorities relocate Indians displaced by the Sioux wars.[44]

The familial recollections of Yankton leaders challenge the progressive narrative of change and cultural dissolution proposed by Jackson and reanimate familiar images by making them sites of contested meanings. Mick Gidley's recent investigation into the interactions between Curtis and his native subjects similarly recomplicates our readings of Curtis's images by revealing the ways in which Curtis's sitters collaborated in the staging of particular pictures, sometimes gaining something of personal value in exchange for their cooperation.[45] How do we sift through these stories? How do we mediate between the stories attached to the pictures when they first entered the public realm and the stories subsequently told by art historians, anthropologists, new-age seekers, or family members?

As a historian and firm believer in the necessity of understanding the historical context of any visual or literary document, I would argue that it is important to try to understand Jackson's needs, Curtis's needs, the needs of all the many nineteenth- and early-twentieth-century photographers who created and marketed pictorial visions of Indian life. Nonetheless, it is critical to remember that these photographs were, by and large, collaborations between consenting adults, each of whom had needs for the pictures. The photographers' stories may have held sway when the pictures were first cast out into the public arena, but there were always other

stories attached to these images. Although some of Curtis's subjects clearly served the photographer's agenda by dressing in unfamiliar and archaic garb, reenacting activities they knew about only secondhand, or posing in recently constructed film sets, it would be wrong to assume that they were unable to imagine how they might use the photographs themselves. Like Sitting Bull or Geronimo, they may have embraced the picture-making process as part of a fair economic exchange. Maybe they sought a memento for a family member or a visual record of a treasured object or rare ceremonial practice. Surely there is a wealth of personal stories for every public story Curtis affixed to his photographs. Addressing the relationship between objects and words in her own culture, the Tuscarora photographer Jolene Rickard writes, "In my community there is a relationship between all the objects that we create and the words that surround us. The words are here to teach and guide us through life; the objects are here to serve the memory and meaning of the word."[46] Curtis's pictures may serve the memory and meaning of his words, but they also serve the memory and meaning of his subjects' stories. In their published form, the pictures may be public and didactic, but they have the simultaneous capacity to be personal and ever-shifting in their meaning.

I argued at the outset that Curtis's work falls into two established traditions of visual representation: an ideological tradition that shaped the content of his images and a commercial tradition that helped dictate how they would be marketed. In truth, however, there is yet a third tradition that is essential to understanding his work, one as old as photography itself: the tradition of native peoples using photographs for their own purposes and inscribing pictures with their own stories. Explaining the role of the photographic illustrations in her book *Storyteller* (1981), the Laguna Pueblo writer Leslie Marmon Silko writes, "The photographs are here because they are a part of many of the stories / and because many of the stories can be traced in these photographs."[47]

In the *North American Indian* volumes, Curtis uses images to fix in our minds a visual record of an imagined Indian past, and with words he underscores the fixed historical parameters of that past. So persuasively does he argue for the diminution of once-vibrant Indian cultures that he makes it difficult for us to imagine the uses to which his pictures might be put if freed of this vanishing-race rhetoric. To understand Curtis or

his intentions for his grand anthropological project we must embrace the directive texts with which he envelops his images. But decoupled from Curtis's words and linked with other voices, the photographs gain in emotional resonance. Reinscribed with the stories of the subjects and their families, stories silenced by Curtis in the construction of his project, the pictures in *The North American Indian* gain in vibrancy and symbolic power. And they become potent reminders that meaning in photographs is not intrinsically apparent or fixed, despite the seeming realism of the subject matter. Every viewer brings to an image his or her own memories, expectations, and stories, thus interpreting its meanings anew. Despite their well-established place in the visual marketplace, Curtis's pictures can still shift in meaning and value as new viewers come forward with their own stories. Thus reimagined, the photographs can transcend their position as time-bound mementos of the vanishing-race ideology and become instead vibrant sites of contested meanings that continue to provoke spirited debate.

Notes

1. Edward S. Curtis, *The North American Indian*, ed. Frederick Webb Hodge, 20 vols. (Cambridge MA and Norwood CT: University Press and Plimpton Press, 1907–30). Mick Gidley's excellent new book, *Edward S. Curtis and the North American Indian, Incorporated* (New York: Cambridge Univ. Press, 1998), provides the most detailed account of Curtis's publishing ventures, offers a critical assessment of Curtis's literary and visual constructions of North American Indian life, and reprints an important selection of documents pertaining to Curtis's project. Other secondary works basic to an understanding of Curtis's endeavors are: Barbara A. Davis, *Edward S. Curtis: The Life and Times of a Shadow Catcher* (San Francisco: Chronicle Books, 1985), and Florence Curtis Graybill and Victor Boesen, *Edward Sheriff Curtis: Vision of a Vanishing Race* (Boston: Houghton Mifflin, 1976).

2. Curtis, *North American Indian*, portfolio 1, list of plates. For more on the logic of the "vanishing race" see Brian M. Dippie, *The Vanishing American Indian: White Attitudes and U.S. Indian Policy* (Middletown CT: Wesleyan Univ. Press, 1982).

3. George Catlin, *Letters and Notes on the Manners, Customs, and Condition of the North American Indians* (1841; reprint, New York: Dover, 1973), 1:3.

4. Cited in Paula Richardson Fleming and Judith Luskey, *The North American Indians in Early Photographs* (New York: Harper & Row, 1986), 22.

5. Christopher Lyman offers an unsympathetic and tendentious reading of Curtis's practice of excluding visual references to contemporary life in *The Vanishing Race and Other Illusions: Photographs of Indians by Edward S. Curtis* (Washington DC: Smithsonian Institution Press, 1982), arguing that if Curtis was truly a purist he would have excluded horses and sheep—as well as alarm clocks—from his images of would-be traditional communities.

6. On Käsebier's Indian photographs see Barbara L. Michaels, *Gertrude Käsebier: The Photographer and Her Photographs* (New York: Harry N. Abrams, 1992), 29–44.

7. Joseph K. Dixon, *Wanamaker Primer on the North American Indian* (Philadelphia: Wanamaker Originator, 1909), 44, cited in Susan Applegate Krouse, "Photographing the Vanishing Race," *Visual Anthropology* 3, nos. 2–3 (1990): 218.

8. Curtis, *North American Indian*, portfolio 3, "List of Large Plates Supplementing Vol. III," texts for plates 87 and 91.

9. For more on the predictive nature of nineteenth-century western photographs see Martha A. Sandweiss, "Dry Light: Photographic Books and the Arid West," in *Perpetual Mirage: Photographic Narratives of the Desert West*, ed. May Castleberry (New York: Whitney Museum of American Art, 1996), 21–29.

10. For more on the publication history of McKenney and Hall's project see Ron Tyler, *Prints of the West: Prints from the Library of Congress* (Golden CO: Fulcrum Publishing, 1994), 38–46.

11. Thomas L. McKenney and James Hall, *History of the Indian Tribes of North America. . . .*, vol. 2 (Philadelphia: Daniel Rice & James G. Clark, 1842), 71, and vol. 1 (Philadelphia: Edward C. Biddle, 1836), [93].

12. On Catlin, see Brian W. Dippie, *Catlin and His Contemporaries: The Politics of Patronage* (Lincoln: Univ. of Nebraska Press, 1990), and William H. Truettner, *The Natural Man Observed: A Study of Catlin's Indian Gallery* (Washington DC: Smithsonian Institution Press in cooperation with the Amon Carter Museum of Western Art and the National Collection of Fine Arts, 1979).

13. Catlin, *Letters and Notes*, 1:92, 145.

14. *Catalogue of Photographs, Published by Bierstadt Brothers, New Bedford, Mass.* (New Bedford MA: Mercury Job Press, 1860). On Bierstadt's western photographs see also Nancy K. Anderson and Linda S. Ferber, *Albert Bierstadt: Art and Enterprise* (New York: Hudson Hills Press in association with the Brooklyn Museum, 1990), 140–45.

15. "[Albert Bierstadt] to Crayon," 10 July 1859, *The Crayon* 6 (Sept. 1859): 287.

16. Ferdinand Vandiveer Hayden, "Contributions to the Ethnography and Philology of the Indian Tribes of the Missouri Valley," *Transactions of the American Philosophical Society* 12, n.s. [Philadelphia, 1863]: 457–58.

17. A collection of Mitchell and McGowan images can be found in the col-

lections of the Nebraska State Historical Society, Lincoln, with related documentation in the Historical Society's artist files.

18. On Morrow, see Wesley R. Hurt and William E. Lass, *Frontier Photographer: Stanley J. Morrow's Dakota Years* (n.p.: Univ. of Nebraska Press and Univ. of South Dakota Press, 1956). A significant collection of his work is found in the Montana Historical Society, Helena. A collection of his backlists is included in "Stereoview Back-lists," comp. J. J. Wilburn and T. K. Treadwell, an undated typescript publication (Bryan TX: National Stereoscopic Association, [1988]).

19. Backlists from Russell's stereoscopic series *Union Pacific R.R. Stereoscopic Views across the Continent West from Omaha* are reproduced in Wilburn and Treadwell, "Stereoview Back-lists." His stereoviews are also listed, without credit, in the Sedgwick publication noted below. For more general information on Russell see Susan Danly, "The Railroad Photographs of A. J. Russell and Alexander Gardner" (Ph.D. diss., Brown University, 1983).

20. For a listing of Sedgwick's stereoscopic slides see *Announcement of Prof. S. J. Sedgwick's Illustrated Course of Lectures and Catalogue of Stereoscopic Views of Scenery in All Parts of the Rocky Mountains, Between Omaha and Sacramento* (New York: Metropolitan Printing & Engraving Establishment, 1873). For more biographical background see William D. Pattison, "Westward by Rail with Professor Sedgwick: A Lantern Journey of 1873," *Historical Society of Southern California Quarterly* 42 (Dec. 1960): 335–49, and the assorted pamphlets, broadsides, and manuscripts in the S. J. Sedgwick Collection, Beinecke Rare Book and Manuscript Library, Yale University.

21. A collection of Z. Gilbert cabinet cards is found in the collection of the Beinecke Rare Book and Manuscript Library, Yale University.

22. *St. Louis Practical Photographer* 2, no. 2 (Feb. 1878), n.p.

23. Fleming and Luskey, *Indians in Early Photographs*, 22–24; Henry quote on p. 22.

24. [Antonio Zeno Shindler], *Photographic Portraits of North American Indians in the Gallery of the Smithsonian Institution* [1869; misdated 1867 on cover] in *Smithsonian Miscellaneous Collections* 14, no. 216 (1876).

25. F. V. Hayden, "Prefatory Note," in W. H. Jackson, *Descriptive Catalogue of Photographs of North American Indians*, Department of the Interior, United States Geological Survey of the Territories, Miscellaneous Publications, no. 9 (Washington DC: Government Printing Office, 1877), iii.

26. Hayden, "Prefatory Note," v.

27. Jackson, *Descriptive Catalogue*, 34, 52, 54, 64.

28. Jackson, *Descriptive Catalogue*, 30.

29. Jackson, *Descriptive Catalogue*, 38.

30. Paul Chaat Smith, "Every Picture Tells a Story," in *Partial Recall*, ed. Lucy R. Lippard (New York: New Press, 1992), 97.

31. *The Daguerreian Journal* 2, no. 5 (16 July 1851): 153.

32. Lynn Davis, *Na Pa'i Ki'i: The Photographers in the Hawaiian Islands, 1845–1900* (Honolulu: Bishop Museum Press, 1980), 16. Richards's quote, cited there, is from his Journal, 30 May 1843, Hawai'i State Archives. Ha'alilio died on his return voyage to Hawai'i in 1844.

33. Julie Schimmel, "John Mix Stanley and Imagery of the West in Nineteenth-Century American Art" (Ph.D. diss., New York University, 1983), 42–44, 47.

34. David Bruce, *Sun Pictures: The Hill and Adamson Calotypes* (Greenwich CT: New York Graphic Society, 1973), 80–81; Colin Ford, ed., *An Early Victorian Album: The Photographic Masterpieces (1843–1847) of David Octavius Hill and Robert Adamson* (New York: Alfred A. Knopf, 1976), 34–35, 287–91.

35. Dolores A. Kilgo, *Likeness and Landscape: Thomas M. Easterly and the Art of the Daguerreotype* (Saint Louis: Missouri Historical Society Press, 1994), 123–29. The circus performance is cited in the *St. Louis Daily Union*, 24 and 25 March 1847, and quoted in Kilgo, p. 125.

36. In his essay on Easterly's Indian subjects, ethnologist John Ewers comments on the clothing of the Iowa subjects Easterly photographed in 1849 but not on that of the Sauk and Fox subjects. See John C. Ewers, "Thomas M. Easterly's Pioneer Daguerreotypes of Plains Indians," *Bulletin of the Missouri Historical Society* 25 (July 1968): 329–39.

37. Kilgo, *Likeness and Landscape*, 125.

38. Jana L. Bara, "Cody's Wild West Show in Canada," *History of Photography* 20 (summer 1996): 153.

39. *Geronimo's Story of His Life*, taken down and edited by S. M. Barrett (New York: Duffield & Co., 1906), 197.

40. All published in *Geronimo's Story*.

41. Reneé Sansom-Flood and Shirley A. Birnie, *Remember Your Relatives: Yankton Sioux Images, 1851 to 1904*, ed. Leonard R. Bruguier, vol. 1 (Marty SD: Marty Indian School, 1985). Interesting readings of Indian portraits by the subjects' descendants can also be found in Lippard, *Partial Recall*, and in George P. Horse Capture's foreword to *Native Nations: First Americans as Seen by Edward S. Curtis*, ed. Christopher Cardozo (Boston: Little, Brown, 1993).

42. Jackson, *Descriptive Catalogue*, 34.

43. Sansom-Flood and Birnie, *Remember Your Relatives*, 4–5.

44. Sansom-Flood and Birnie, *Remember Your Relatives*, 10–11, 16–17, 19–20, 25–26.

45. See his essay in this volume.

46. Jolene Rickard, "Cew Ete I Tih: The Bird that Carries Language Back to Another," in Lippard, *Partial Recall*, 108.

47. Leslie Marmon Silko, *Storyteller* (New York: Arcade, 1981), 1.

Ways of Seeing the Curtis Project on the Plains

MICK GIDLEY

Edward S. Curtis's *The North American Indian* (1907–30) is a monumental set of twenty volumes of illustrated text and twenty portfolios of large-size photogravures. My guess is that it is a text more famous than read—partly because of its size, its millions of words and thousands of images, but most obviously because it was originally sold in a severely limited edition on a subscription basis to major libraries and wealthy individuals. But it *is* famous, and since the revival of interest in Curtis that occurred in the early 1970s, its images, especially of plains peoples, have become pervasive. Curtis's Indian pictures not only regularly illustrate books, articles, films, and television programs about Native Americans, they also often decorate calendars, appear in poster form, embellish stationery, and have been used to advertise a variety of products, from organic foods to boots and shoes.

This pervasiveness means that *The North American Indian* appears to be better known than it is. Its hugeness—and just as importantly, the scale, duration, and complexity of the project to produce it—makes it, in fact, hard to know. In the first half of this essay I will expand upon this

point. I wish to show that the project's magnitude—the variety of its activities, the forces at work in it, and so on—means that it is possible to tell a number of *different* stories about it and, most significantly, to find support somewhere in it for a variety of interpretations of its vision of Native Americans. In the second half of the essay, which also enables the reader to witness some little-known episodes in the project's activities among the plains peoples, my contention is in fact that different representations of "Indians" emerge depending upon which aspects of the enterprise we see. In other words, this essay is about ways of seeing as much as it is about the topic being witnessed.

The Scale of the Curtis Project

We must first consider the subject matter of *The North American Indian*: over eighty distinctly different Native American peoples living in the United States, Canada, and Alaska west of the line of the Mississippi River who, in the words of Curtis's preface to volume 1, "still retained to a considerable degree their primitive customs and traditions." Leaving aside the discredited notion of the "primitive" employed in Curtis's formulation here, this geographical and cultural range is enormous, encompassing deserts, prairies, tundra, mountains, and much else; if we were to compare it with Europe we would be thinking of a variety of locales and peoples extending from Gibraltar at the southern tip of Spain to at least the Ural Mountains in Russia. During his own lifetime Curtis himself was often at pains to disabuse people of the idea that a statement about one Native American group could necessarily be applied to any other. "If [they] say 'the Zuni believes so-and-so', all well and good," he said, "but when they say 'the Indian', it is quite a different matter." At the same time, and this is an issue to which we will return, Curtis himself also acknowledged that "The Northwest Plains Indian is, to the average person, *the* typical American Indian, the Indian of our school-day books—powerful of physique, statuesque, gorgeous in dress, with the bravery of the firm believer in predestination."[1]

The duration of the efforts that produced *The North American Indian* also contributed to its elusiveness. Work toward what became the text of the multivolume work, especially picture-making activity, actually

began some years before the first volumes were published in 1907 and did not cease until the final volume—devoted to the so-called Eskimo peoples of Alaska—appeared in 1930. Curtis, who was born on 19 February 1868, probably learned the basics of photography in a Saint Paul or Minneapolis studio before migrating to the Puget Sound region in 1887. He first bought into a Seattle photographic and engraving business in 1891. Within just a few years he was running his own company, which became *the* portrait studio for the fast-growing city. He was a gifted photographer in a range of genres, and through reading, personal relationships, and as time went on, direct exposure to the exhibited work of major pictorialists of his own generation, he became well acquainted with fashionable trends in the medium. He began to bring these attributes to the photography of the local Coastal Salish people of Puget Sound, probably as early as 1892. By 1895 he had definitely made several powerful images of Princess Angeline, the daughter of Chief Sealth, from whom Seattle had taken both its name and its title to the land. Curtis's images—his landscapes, his portraits, and most of all what were known as his "picturesque genre studies" of indigenous people—began to be widely circulated and to receive praise and prizes. Partly out of opportunism, in that it was so immediately successful, Curtis increasingly devoted disproportionate amounts of time and energy to the making of his "Indian series."[2]

Then, from 1900 at the latest, he began to conceive of turning this work, by now a semicoherent collection, into a major publication project. For some years, during which he expended much of the proceeds of the Seattle studio on photographic field trips to many parts of the West, he sought patronage for the large-scale enterprise from a range of possible sources, including government agencies, scientific institutions, and affluent individuals—industrialists, landowners, and philanthropists. At the end of the 1904 season—which Curtis spent mostly in the Southwest culture area, working with a variety of the peoples of New Mexico and Arizona—he told Frederick Webb Hodge, a new friend he had acquired at the Bureau of American Ethnology (BAE) in Washington DC, that he wished to return to the Southwest soon, particularly to the White Mountain Apaches, "more for *information* than pictures."[3] What was to become *The North American Indian* was taking shape. Finally, in February

1906 Curtis secured funding from the fabulously wealthy J. Pierpont Morgan for what we now know as *The North American Indian*, complete with both "pictures" and "information."

This long gestation period, followed as it was by the protracted labor leading to the births of each volume—some of these births characterized by extreme delay—left marks on *The North American Indian*. The photographs, for example, are difficult to date with any real precision from the information given in the text. The dates in the text are when they were submitted for copyright, but this was usually when they were about to be published for the first time, and first publication might well have been in a magazine article or as a postcard rather than printed on tissue in photogravure form in the plushness of *The North American Indian* itself. Thus, the famous image *The Three Chiefs—Piegan* (plate 33), of mounted Blackfoot warriors, was "copyright 1900" and appeared in a newspaper item the same year, but it was not published in *The North American Indian* itself until volume 6 came out in 1911. As it happens, this image was copyrighted in the likely year of its making, but in the case of many others, especially those published for the first time in *The North American Indian*, to take the copyright date as the definite time of creation would be at least mildly misleading and could be a mistake. We know from a manuscript account of a field trip among the Piegan undertaken with Curtis by the leading British anthropologist Alfred Cort Haddon "[e]arly in August, 1909," as Haddon put it, that several much-reproduced images were made during the weeks of that visit.[4] But the copyright dates given on these images—*Yellow Kidney* (plate 74), for example, or *Tearing Lodge* (plate 70), or, most famously, *In a Piegan Lodge* (plate 21)—was not 1909 but 1910. Some of the volumes—perhaps most spectacularly those devoted to Coastal Salish groups (vol. 9, 1913), the Hopi people (vol. 12, 1922), and the Pueblos of New Mexico (vols. 16 and 17, both 1926)—contain images made as much as a quarter of a century earlier alongside ones produced as close in time as the previous summer.

Sometimes the written text, too, is almost a palimpsest. This is true of the volumes devoted to the plains peoples who constitute our primary focus. Since the relevant six volumes of *The North American Indian* appeared in two sequences, the first (vols. 3 through 6) between 1908 and

1911 and the second (vols. 18 and 19) much later, between 1928 and 1930, Curtis and his associates inevitably dedicated many visits over an extended period to the gathering of data on this expansive culture area. While in this essay I will be concerned exclusively with the fieldwork that fed predominantly into the earlier sequence of volumes, it is important to realize that some of the data in the later sequence was gathered considerably earlier. The prefaces to the volumes do give an indication, it should be said, of such disparities, but they rarely do so with sufficient specificity for the reader to be aware of the passage of time, to witness the subject peoples in the process of change. There are ironies implicit here to which we must return. The project's extended duration might readily lead us also to wonder whether *it*—its preoccupations, approaches, practices, and procedures—changed over time.

The Collective Nature of the North American Indian Project

Another feature of *The North American Indian* that likewise contributed to what I have called its hardness to know is that throughout its lengthy production many more people than Curtis were involved. The present essay is not the place for more than a severely condensed history of the project. Suffice it to say that the Morgan largess enabled Curtis to run a sizable organization—in fact, by 1910 at the latest, this organization, headquartered in New York, had become a business, The North American Indian, Incorporated. The Seattle studio was allocated a full-time manager, Adolf F. Muhr, who was himself a photographer of Indians. Although they are often credited exclusively to Frank A. Rinehart, most of the portraits of the chiefs brought to Omaha's Trans-Mississippi Exposition in 1898 had been made by Muhr. During the early years of *The North American Indian*, he also handled much of the publication's darkroom work.[5] Frederick Webb Hodge, Curtis's friend at the BAE and a key facilitator in the fledgling field of anthropology in the United States, was engaged as editor of the published volumes on a freelance basis, at so many dollars per thousand words.

Assistants were hired to compile the ethnological data, sometimes enough of them for several parties to be set to work in different locations

at the same time. The first principal—and self-trained—ethnologist was William Washington Phillips, Curtis's nephew by marriage. But the key figure as chief ethnologist and, quite rapidly, writer of *The North American Indian*, at least through volume 18, was William Edward Myers, a former newspaperman with excellent shorthand and a gift for languages. Myers, too, trained himself on the job by listening, but he was also an avid reader of published ethnography, to keep abreast not only of work on the peoples he was studying but of theoretical concerns as well, and he maintained links with such academic anthropological luminaries as Alfred Kroeber of Berkeley. When Myers quit The North American Indian, Inc., he was succeeded by Stewart C. Eastwood, a young man who had studied at the University of Pennsylvania with Frank Speck, the authority on Eastern Woodland peoples. It was Eastwood who wrote most of volume 19, on such southern plains peoples as the Comanches, Southern Cheyennes, and Wichitas.

Equally crucially, from the ethnological point of view, the Morgan money made it feasible to employ Native American informants and interpreters on a regular basis. Interpreters were usually recruited out in the field as the project progressed, but key informants and link personnel were arranged ahead of time or even kept on a retainer. Some of these figures—Davy Bear Black, an interpreter who helped out among the Cheyennes, for example—appear in records I will be quoting later. Probably the most important Native American fieldworker was Alexander B. Upshaw, an educated Crow who worked casually with Curtis and his associates in the summer of 1905 and on a regular basis from early 1906 until his death in 1909. Born in 1875, the son of Crazy Pend D'Oreille, a Crow warrior whose name was a byword for fearlessness, Upshaw graduated from the Carlisle Indian School in Pennsylvania in 1897, became an Indian School teacher himself, and married. By the time he came to work for the Curtis project, he had largely turned his back on white ways and was furthermore much admired by his own people as a tireless campaigner for Crow land rights. He was able to get the confidence of the older folk so that the plains culture area volumes of *The North American Indian*—especially the one on the Crows (vol. 4)—came to be acknowledged as rich collections of data and have been frequently cited by later

respected anthropologists of plains cultures such as Robert Lowie and John Ewers.

Several other figures worked for the project in the field, some more as clerical assistants than as ethnologists; these included Edwin J. Dalby, who was recruited through Curtis's friend at the University of Washington, history professor Edmond S. Meany, and Edmund A. Schwinke, himself a neophyte photographer. On occasion, a field party would be augmented by associates from Seattle such as Meany, by prominent visitors such as A. C. Haddon, or by one or other of Curtis's children. In effect, a (changing) team, usually including a camp cook, was put together. This means that—and I cannot stress this enough—the project was a *collective* endeavor. Moreover, it produced not only *The North American Indian* itself but attendant photographic exhibitions, two "supplementary readers" for the general public, lectures, the 1911 epic entertainment called the "musicale" or "picture-opera," popular magazine articles, the very first feature-length narrative documentary film, *In the Land of the Head-Hunters* (1914), and of course, vast numbers of photographs reproduced in countless outlets. It is true that Curtis was the prime mover and dynamo throughout these activities, but we are probably talking about the largest anthropological project ever undertaken, and we should not attribute all of its manifold characteristics to Curtis alone.

The Project in Context

Indeed, as I have claimed elsewhere, in speaking of the "coordinates" for the project, it was subject to the "controlling logic of culture"; it—and therefore the representation of Native Americans it produced—was unique, and yet paradoxically perhaps, it was also entirely typical of its time(s). Following this line, allow me to advance some bald statements. The project was embedded, if sometimes uneasily, in the American political and financial establishment. President Theodore Roosevelt wrote the foreword to the first volume of *The North American Indian* and, just as significantly, allowed his name to be coupled with it for publicity purposes. Likewise, there was a much closer correspondence of assumptions between the enterprise and the federal government's Bureau of Indian

Affairs (BIA) than might be expected, not only in Roosevelt's time but throughout the duration of the project. As we have seen, J. Pierpont Morgan, then literally the richest person in the world, provided most of the funds, and other patrons included several bankers, the railroad tycoons Edward H. Harriman and Henry E. Huntington, U.S. Chief Forester Gifford Pinchot and similarly placed government officials, and Andrew Carnegie and a variety of other prominent industrialists. Indeed, the thesis of *The West as America*, by William H. Truettner and others, that much Western art reflected the entrepreneurial, even exploitative, aspirations of America's financial elites, could profitably be applied to the North American Indian project.[6]

Moreover, certain establishment scientists—George Bird Grinnell, editor of the national journal of outdoor life *Forest and Stream*, for instance, or the Smithsonian's Charles Doolittle Walcott—gave both their support and intellectual credence to the project and its business. Grinnell, a man who had himself devoted many summers to studying northern plains peoples, especially the Piegans, Pawnees, and Cheyennes, was probably Curtis's most significant early mentor. In 1900 (or possibly 1898) Curtis accompanied the older man on a visit to the Piegan sun dance—a religious rite in which young men fast and suffer severe mortification of the flesh in pursuit of visions—and, according to Curtis family lore, he was so moved by the experience that it was then that he committed himself to the task of creating a comprehensive record of such ceremonies as a kind of monument to their indigenous makers. Later, in 1905, Grinnell composed a laudatory essay about Curtis's "Portraits of Indian Types"—illustrated by visual examples—and placed it in *Scribner's* for maximum national effect.[7] Such figures as Grinnell and Walcott tended to be old-school "natural historians"; they envisioned native peoples—in sharp contrast to so-called civilized peoples—as part of the continuum of "Nature," together with geological formations and flora and fauna, rather than as exemplars of varieties of *cultural* behavior in the manner of Franz Boas and the proponents of anthropology as a new social science discipline. The paleontologist Henry Fairfield Osborn, president of New York's American Museum of Natural History, the man who actually introduced Curtis when he mounted the musicale at Carnegie Hall, was

not only a long-term opponent of Boas but also became an influential scientific racist in the second decade of the twentieth century.

In light of such connections, Curtis's oft-expressed belief that Native Americans were a "vanishing race" doomed to extinction, peoples whose lifeways were in urgent *need* of recording and memorialization, requires fuller contextualization. His 1904 picture of a line of Navajos riding away from the camera toward the engulfing shadows of canyon walls—a picture actually titled *The Vanishing Race* (1904)—was selected as the keynote initial image for *The North American Indian*. Its caption reads: "The thought which this picture is meant to convey is that the Indians, as a race, already shorn of their strength and stripped of their primitive dress, are passing into the darkness of an unknown future." Ideologically, Curtis's Indians, as I have several times argued, would frequently ride into the darkness of an unknown future. Moreover, looked at in aesthetic terms, Curtis inherited the patterns of representation of his nineteenth-century predecessors in the medium, as described by Martha Sandweiss in this book. He was also, as I intimated above, steeped in pictorialism, the dominant photographic art movement during his formative and middle years, particularly as manifested in the Photo-Secession, the art photography movement founded and fostered by Alfred Stieglitz, Edward Steichen, and others during the first decade of the twentieth century. The Photo-Secession promulgated aesthetic values and techniques that are also evident in Curtis's work. For example, we can see at once that *The Vanishing Race*, with its murky shadows in which we can just discern that the penultimate rider has turned in the saddle to look back, as if in regret, has eschewed any claim to precision—to what one proponent of pictorialism castigated as "the *niggling* detail, the factual accuracy of sharp all-over *ordinary* photography"—in favor of what the same writer termed "concentration, strength, massing of light and shade, breadth of effect."[8]

In 1901 Arnold Genthe, probably the best-known pictorialist on the West Coast, praised Curtis in detailed pictorialist terms: "E. S. Curtis's Indian studies . . . are of immense ethnological value . . . and most of them are really picturesque, showing good composition and interesting light effects." " 'The Moqui Chief,' " he continued, "is a stunning portrait of the haughty Indian. . . . 'The Three Chiefs' [plate 33] just misses

being great. If the head of the foremost horse could have been turned so as to break the straight line formed by the three horses the composition would have been perfect. But, even as it is, the photograph is a very beautiful rendition of the picturesque phase of Indian life." Grinnell, not himself an artist, believed that Curtis's mission was "to picture the Indian as he was in primitive times . . . unposed, unartificial, living his daily life, going about his daily affairs." "But," Grinnell added, "he considers also—and, I fancy, considers chiefly—the art side. . . . It is through the manipulation of light and through beauty of line and of composition that Curtis is able to make his personality felt."[9] Two contrasting classics of pictorialist composition are the portraits of the Sioux leaders *Red Cloud—Ogalala* (1905; plate 13) and *Little Hawk* (1908; plate 66), a Brulé, probably photographed in 1907. Red Cloud, who had been an enormously influential figure in Indian-white relations during the late nineteenth century, was depicted in his blind old age: the camera appears to look slightly downward, accentuating the lines of age, capturing a wistful dignity. Little Hawk, on the other hand, is pushed up into a narrowed frame and his chest "lost," so to speak, which has the effect of dramatizing him in vigor and pride.

Representing *The Vanishing Race*

There were definitely, in other words, political, economic, ideological, and aesthetic constraints and contexts to the project's representation of Native Americans. Curtis himself, of course, did not see the project this way. For the most part, he presented *The North American Indian* as a straightforward "record." In one of the intermissions during the 1911 musicale performance, for example, in telling the audience "a little of the purpose of the work," he said, "It is an effort to make a broad picture and word record of the Indians." He liked to be known as a "photo-historian"—indeed, "*the* photo-historian"—of indigenous America. In 1914, at the height of his fame, he published in the *American Museum Journal* his "Plea for Haste in Making Documentary Records of the American Indian." "What is true of man in his earlier types applies to all anthropological records," he claimed. "We value the skull, the skeleton, the artifacts, the clothing; but beyond these we want the documentary

picture of the people and their home-land—a picture that will show the soul of the people." "In the study of primitive man," he continued, "the interest is more in his psychology than in his economics, more in his songs and prayers than in his implements. In fact, we study his implements that we may get light upon his mental processes."[10]

Records are never in fact straightforward or neutral: in this case, they would even, Curtis hoped, reveal "the soul." Records, however "documentary," are not, of course, reality itself but *representations*. They come to us shot through with all the assumptions of the individual and the culture that produced them. This was something that Curtis himself almost acknowledged when, as we have witnessed in comments quoted earlier, he related his record and the urgency of it to the notion of "the vanishing Indian." In the musicale intermission speech he stressed the immensity of the project, asking, "Is the subject worth so great an effort?" He answered thus: "Posterity will say, Yes, a thousand times yes. The Indian, one of the four Races of Man, is fast disappearing from the earth. In a few brief years he will be but a tradition. . . . The history of the world does not, will not, show anything comparable to their annihilation." And it is important to realize that this was a sentiment widely shared at the time. It was indeed a cultural assumption. William Henry Holmes, the artist, anthropologist, and one-time chief of the BAE, wrote to Curtis: "[Y]our idea is a grand one—the preservation for the far future of an adequate record of the physical types of one of the four races of men, a race fast losing its typical character and soon destined to pass completely away."[11]

Gertrude Metcalfe, moreover, like many others, saw the project as a national endeavor, arising out of "a fine, high patriotism":

A Western artist . . . with rare genius for penetrating the mask of Indian nature, is making it his life-work to preserve by the aid of the camera the essential characteristics of these vanishing tribal types. . . . In a lightning flash of sympathy [Curtis] has succeeded in catching with his camera the ancient, elusive glory of the native American. . . . A survey of the world informed him that aboriginals have always vanished utterly. . . . [He] has made the North American Indian a notable exception. . . . No other nation has ever possessed a record so magnificent of the primeval people it supplanted.[12]

To Curtis and to many others of his time who shared the belief that Native Americans were a vanishing race, *The North American Indian* was both a record and a monument.

Visual Representations of the Dominant Ideology

At the outset here I claimed that a variety of stories could be told about the project, and that the "way" of "seeing" determines what is seen. In turning more particularly now to the plains, I must first acknowledge that there is a crucial way of seeing missing here: the perspective of the subjects of the project, the people mistakenly regarded by Holmes and others as disappearing, the Native Americans who sat for their portraits and who communicated their histories, beliefs, and lifestyles to project workers. In 1987 Anishinaabe author Gerald Vizenor, speaking of Curtis's images, wrote, "[W]e were caught dead in camera time, extinct in photographs," and suggested that "now . . . in search of our past and common memories . . . we walk right back into these photographs." This kind of reclamation research, usually undertaken by Native American scholars, has indeed started. It is evident in such collections of Native American responses to photographs as Lucy R. Lippard's *Partial Recall* (1992), in the indigenously oriented *Spirit Capture* exhibition and book sponsored by the National Museum of the American Indian in 1998, and, more internationally, in the show *Native Nations: Journeys in American Photography*, also mounted in 1998, at the Barbican Centre in London. In the particular case of Curtis's images, George Horse Capture (A 'ani—Gros Ventre), one of whose own ancestors Curtis depicted in *Horse Capture—Atsina* (1908; plate 46), has written of the meaning of the image to his family descendants, and at a Smithsonian seminar on Curtis in November 1998 he was joined by Gloria Cranmer Webster (Kwakiutl) and Hartman H. Lomawaima (Hopi), who offered contrasting indigenous perspectives on the enterprise. Duane Niatum's response to Curtis's images, as registered in his essay in this book, might be considered partly in this light. With this sort of work in mind, I felt it appropriate to conclude my recent study of the Curtis project with the claim that it provides a set of texts—a resource—to be exploited, to be played with, even to be played against.[13]

Something that becomes almost immediately apparent when we consider the project from this perspective—as indeed, Martha Sandweiss's essay here also shows—is that, precisely because they were regarded as "ethnographic images," Curtis's Native American portraits emphasize ethnic typology as much as, if not more than, individual likeness. This is most crudely obvious in an image like *Spotted Bull—Mandan* (1908; plate 50), where the caption reads "Not a true Mandan type. The face shows evidence of alien blood, possibly Dakota." (Another Mandan, Yellow Owl [plate 19], by contrast, was described as "a pure type.") Richard Brilliant, writing of the use of "Indian" figures in painted portraiture, has pointed out that, when compared with sitters treated according to the ordinary conventions of portraiture, "ethnographic types" are presented with much more emphasis on "the externals of appearance, especially costume [and] hair treatment."[14] This observation holds true for very many of the plains photographic portraits produced by the Curtis project. Lots of them include caption commentary on costume. Let me offer just two examples from the Blackfoot confederacy: *Iron Breast—Piegan* (1900; plate 22) and *Bear Bull—Blackfoot* (1926; plate 17). The caption to the first reveals that the costume was that of an "obsolete" society, and that to the second claims that it illustrates an "ancient method of arranging the hair." Even when the caption does not draw attention to such matters, the image itself does: the profile of *Two Whistles—Apsaroke* (1908; plate 60), complete with a stuffed bird at the back of his head and white paint daubed down his face, for example, or the beautifully robed *Shot in the Hand—Apsaroke* (1908; plate 27).

In all portraiture there is a tension between the rendition of the sitter's individuality or unique being and that of his or her social role (the soldierness of the soldier, for example), but when the emphasis falls predominantly on social attributes—sometimes *despite* very powerful "natural" features, whether lines of age, for instance, or delicacy of proportion—it reinforces the notion that *group* identity is paramount: in this case, the "Indianness" of "the Indian" or, just as likely, the Mandanness of the Mandan, the Siouxness of the Sioux, and so on. Curtis thus depicted Upshaw not as he usually saw him—in dungarees, with short hair neatly parted—but bare-chested and adorned with feather headdress (plate 54). In general, there was a concentration on "tradi-

tional" ways, even to the extent of issuing wigs to cover shorn hair, the provision of costumes, and the erasure of signs of mechanistic aspects of the twentieth century. Christopher Lyman pointed out some time ago that the copyright version of *In a Piegan Lodge* included a clock between the two seated figures, but it was retouched away before the image appeared in *The North American Indian* (plate 21). Similarly, each of the plains volumes offers sequences of images that seem to follow the "stages" of a war party despite the fact that, at the point at which they were made, there were no war parties and everyone involved was confined to a reservation. The Atsina coverage, for example, includes *War-Party's Farewell* (plate 47), through *Awaiting the Scout's Return* (plate 48) and *The Scout's Report* (plate 2), to other images of like action, all dated 1908 and probably all made at the same time the previous year.[15]

Very many of these plains views—such as *The Old Cheyenne* (1927; plate 89), in which an ancient rider displays a human scalp—were in fact reconstructions or, more accurately, *constructions* produced at the behest of a prevailing ideology. One image of a mounted Crow war party, taken in 1905, is called *The Spirit of the Past* (1908; plate 56). And the spirit of the past was also constructed in several of the views of religious rites. Three such Oglala Sioux images, each dated 1907, seem particularly compelling: *Prayer to the Mystery* (plate 10), *The Sun Dancer* (plate 5), and *Invocation*. In each there is the sense of a *tableau vivant*, of the holy man frozen in eternal supplication. This transcendentalist effect tends to remove the subject from the passage of time, from history and its all-too-human messiness, altogether. Historical change as it actually affected these people is kept at bay.

The Project's Contradictory Representations

There are other features of the images that I would discuss if space permitted. There is a propensity, for example, especially noticeable in the plains work, for patterns of composition to be repeated: it could be argued, say, that *Bow River—Blackfoot* (1926; plate 36), with its mounted horseman at the water's edge, imitates the evocative structure of the more famous *An Oasis in the Badlands* (1905; plate 90), which presents a Sioux warrior posed in a very similar position in 1904. Such repetition,

or better, variation on themes in itself suggests a sort of standardization of imagery, the formation and perpetuation of an iconography. But I need to examine further aspects of the project's intertwined yet competing or contradictory representation(s) of plains cultures—partly in the light of the published text of *The North American Indian* and partly in connection with unpublished or uncollected contemporary newspaper items, field notes, and reminiscences. As we will see through just a small selection of examples, the representations produced in writing by the North American Indian project are at least as complicated as those we have witnessed in the visual imagery. (Because these examples rely on previously unpublished or uncollected material they are quoted in some detail.)

W. W. Phillips wrote an unpublished memoir about the project's experiences on the Northern Cheyenne reservation in southeastern Montana. It concerns incidents that most likely took place in 1905 and is extracted from "With the Cheyennes," a "chapter" of the reminiscences that Phillips probably composed in 1911, at roughly the same time as the Cheyenne volume (6) of *The North American Indian*.[16]

Curtis, Upshaw and I, with fresh supplies, decamped on the upper Rosebud stream, along which numerous Cheyenne camps were strung. "Haste," was the watchword of that brief sojourn and pictures the primary object, for plans provided for a revisit a year or more later. The camp site was decided upon at noon; by night the big photo tent, a square "A" sleeping tent, and a "catch-all" Indian teepee adorned a small fenced-in patch that lacked little of being an island, and a dozen or more Cheyenne portraits had been taken.

With a youthful Cheyenne Indian, Davy Bear Black, as interpreter, I rode about telling the Indians of our purpose and asking them to call at camp and see us. They did so, scores of them. . . . The Cheyennes were pictures of poverty. [T]hey had almost no live stock. The chance of getting a square meal, of selling some bit of handiwork, or being paid for a portrait, appealed to them. Soon our camp became a busy scene. . . . We fed as many as twenty at a meal, sometimes, old and young, men, women and children.

The poverty referred to here—literally amounting to starvation in some instances—was a feature of plains life during the early years of the

twentieth century. A nomadic, hunting lifestyle had become untenable, was in fact forbidden by the BIA, and farming was not yet properly established; plains peoples were at the mercy of rations supposedly guaranteed by treaty. Harold Phillips Curtis, Edward's son, vividly remembered witnessing starvation among the Sioux during the same period.[17] For Phillips, leaving the Cheyennes was equally memorable: "[T]he day we left . . . with a two day's drive ahead, we didn't have food enough in camp to fill a soap-box. To have to leave so hastily with a score of wistful faces and hungry mouths gazing after us disappointedly . . . was a necessity that then did, and has since, filled me with compassionate regrets." However, when we read the text of the Cheyenne volume of *The North American Indian*, none of this appears. The Cheyennes are *not* depicted there—in either photographs or words—as, in Phillips's words, "pictures of poverty." Nor is it surprising, perhaps, that the volume did not vouchsafe that its very production was made possible, in part at least, by the suffering of the people who were its subject.

The North American Indian, in other words, hides the processes of its own composition. It would be possible to provide many other instances of this. But—and here we see the slippery complexity of the problem—this is not a straightforward matter of the memoir or the unstudied newspaper account being "true" while *The North American Indian* is "false." Another instance shows, in fact, the reverse.

In 1900 Curtis submitted to an interview with a reporter from the *San Francisco Sunday Call* that became the basis for one of the earliest newspaper accounts of his activities as he began to establish a national reputation. I will focus only on the part concerning the Blackfoot, or Piegans, of Montana:

I found these Indians comparatively easy to photograph, thanks to the intervention of White Calf, in addition to the usual "open sesame"—money. However, despite even this combination, I had some trouble and once almost lost my scalp. It is the custom of the men to collect the logs for the lodges constructed for the sun dance. I wished to get a picture of them riding back from one of these wood sorties and stationed myself accordingly. Three horsemen dashed into sight, at the head an Indian called "Small Leggins," who had a particular disgust for the camera. I got the picture, but the quick

eyes of "Small Leggins" saw what I was about and with an angry cry he headed his horse for me, intending to ride over me. By a miracle of good luck Chief White Calf, riding from the other direction, saved my life. Afterward I won the friendship of Small Leggins, but he never lost his distrust for the camera.

White Calf, though he urged the others to pose, was very coy when it came to taking the medicine himself. Finally he consented. I was anxious to get him not only because he was chief but he is one of the few baldheaded Indians I have ever heard of. He appeared as promised, but alas! instead of the picturesque everyday garb he was got up regardless in a faded misfit blue uniform, obtained heaven knows how. His bald head was covered with an elaborate blond wig, on which perched an army hat several sizes too small.

The sun dance ceremony did indeed feature prominently in volume 6 of *The North American Indian*: there was an extended, illustrated account, including an image of riders bringing in the willows for the sun dance sweat lodge. Also, White Calf received recognition as a very prominent chief and his portrait was reproduced there (plate 71). Interestingly, though, in this portrait he is wigless—in fact, he seems to have enjoyed a very full head of hair—and he is "appropriately" dressed: at his shoulder a small stuffed bird, across his chest the wing of a hawk. Small Leggins, on the other hand, went totally unmentioned in *The North American Indian*. At the same time, he was mentioned in other publications put out by the project: in fact, he was listed as one of three "chiefs" (plate 33) depicted in the famous 1900 image of that title when it was used as an illustration for Curtis's *Scribner's* article on the plains.[18]

If *The North American Indian* tended to erase the signs of its own composition, to give the reader the sense that he or she has entered a different but seamless world, at the other extreme a popular newspaper item like that in the *Sunday Call* positively seems to revel in the process of construction. This is partly to enhance Curtis's personality as an indomitable westerner (he is presented as "one of the fortunate few" whites to be allowed to witness the sun dance) and partly to deconstruct any sense of native nobility, perhaps deliberately to denigrate "red men"; it opened with commentary on precisely the difficulties of photographing "the Indian" ("The Indian is the photographer's Waterloo"). Looked at this way, the *Scribner's* essay is at a crossover point between the two: laudatory

about *The North American Indian*, of course, but also reasonably respectful toward Native Americans because here they must be seen as a subject suitable for major study. But, true to this middling position, the article also includes commentary on the then-present circumstances facing Native Americans and appears to accept, if with discomfort, the inevitability of their "extermination."

Versions of Incidents on the Plains

Let us return to Phillips's memoir of the project's 1905 trip to Cheyenne country. It is worth noting that none of its discursive material was incorporated into the Cheyenne section of volume 6 of *The North American Indian*, including the following graphic account of a healing ceremony. Even the figures featured in it were not mentioned in the larger study. We will look at the incident and then try to figure out why this might be.

Brief as was our stay, it was replete with incidents and happenings quite Indianesque. . . . Between eight and nine one evening a wagon stopped in the road opposite camp, some distance away, and a stoutly built man strolled over to where several of us were enjoying a brisk fire. He was a half-Crow, half-Sioux Indian married to a Cheyenne woman. He talked a little of four languages, including English, though none any too well, so found no difficulty in conversing with Upshaw, for signs could be resorted to if words failed. We soon learned that he was on his way up stream to the home of a medicine-man—young Davy Bear Black's father—with a sick baby. The distance was not great . . . so when he drove on with his wife and child, Curtis, Upshaw and I followed in the hope of being privileged to witness the performance that would take place over the baby.

Arriving at the house where Bear Black the elder and his large family lived, we found the stout fellow there, but his wife and infant were not in sight. Our purpose was at once made known to the medicine-man, through his boy; then we waited. . . . What the decree was regarding us we could not conjecture, but steadfastly we waited. By and by Upshaw . . . came and called us, ushering us to a round teepee some distance beyond, made discernible in the darkness by a fire inside. A piece of canvas covered a doorway so low that we had to drop on our knees to enter. We crawled in, all three of us. A small

fire, of well burned coals, on which steeped a pot of herbs, occupied the center. On the right sat the mother with her peevish infant; on the left stretched an old, old Cheyenne, once a prominent medicine-man, but now deaf and blind; back of the fire Bear Black was making ready medicine paraphernalia—feathered wands, rattles and other articles.

The child was feverish and limp, with every appearance of being very ill. Bear Black took it and placed it on a furred skin before him. Pressing his hand to the earth, he then rubbed the bottom of one little foot. Again he pressed the earth, then rubbed the sole of the other foot. The palms of the baby's hands and its forehead were next gently rubbed; and then from sole and palm along the child's limbs to its chest Bear Black glided a hand, rubbing over the heart, each time first touching the earth. The mother then took the babe on her lap, and from the steeping herbs a swallow of medicine which she regurgitated into its mouth. The little one made a wry face, sputtered and cried, but swallowed the dose nevertheless, for it soon vomited.

After that Bear Black began sucking blood from the little one's body, through the skin. He began at its feet and hands, and sucked at spots all over its body several times spitting crimson blood onto the fire. When he had finished, the child seemed quieter; its mother wrapped it up and hugged it close in her arms. . . .

The next morning early, a happy father and mother with a baby as bright and well as a child could be, stopped for a short time at our camp as they drove homeward, down the Rosebud Creek.

One possible explanation for the omission of this material from *The North American Indian* is that—since the incident happened during an early visit primarily centered on pictures—it was simply not remembered at the time of the text's composition, which largely fell not to Curtis or Phillips but to Myers. It is more likely, though, that it did not satisfactorily fit any of the criteria and categories by which data for the Cheyenne volume was selected and organized. It seems, from such other accounts of Cheyenne medicine as those offered by John Stands in Timber, that what Phillips saw was, if anything, too typical. Although the healing practice as witnessed by Phillips appears to have accurately reflected Cheyenne practices in its emphasis on the sucking out of offending matter, it was probably not considered "big" enough in itself to warrant in-

clusion.[19] It was too ordinary, an unnamed rite, whereas most of the parallel data on healing in *The North American Indian* is devoted to more extended ceremonies—in short, the spectacular.

This interpretation is borne out by the fact that a similar fate befell almost all the incidents recalled in some detail in Haddon's "Among the Blackfoot Indians of Montana," the manuscript account referred to earlier. This was probably composed in 1914 and described a 1909 field trip to the confluence of Two Medicine River and Little Beaver Creek, not far from Browning. It is true that much material parallel to Haddon's observations appeared in the Piegan section of *The North American Indian*, volume 6, especially verbal and pictorial portraits of some of the Native American figures they encountered and a probing passage on sacred bundles, a topic to which Haddon devoted several pages.[20] However, as in the coverage of Cheyenne medicine, *The North American Indian* does not provide the kind of detail given by Haddon with respect to more "ordinary" activities, such as sweat lodge practices. In *The North American Indian* it is true that there are frequent references to these activities, but Haddon offers a full description. For example, his account of how Little Plume and his wife made a sweat house for the extremely aged Tearing Lodge is so detailed as virtually to constitute instructions, and once the ceremony is under way, each stage is meticulously enumerated:

Before going in Tearing Lodge sat outside the house and made a long prayer. Mr. Curtis and I were invited to sweat, and we went in with five Indians about 6 p.m., all having divested ourselves of clothing, save for a loin cloth. The entrance of the house was to the east and Tearing Lodge sat in the west facing the entrance.

When we had all sat down on the layer of sage grass a piece of hot charcoal was placed in front of Tearing Lodge, who broke off fragments from a plait of sweet grass and placed them on the coal to make incense. Little Plume, who remained outside, handed in a pipe which was passed to Tearing Lodge; he repeatedly fumigated each end and passed his hand along the pipe and then held it stem upward. He handed the pipe to the man on his left hand who smoked it, then he passed it on to the next man, and so it was handed on, each taking a few puffs, till it reached the man at the entrance to the house [and] as a pipe may not be passed across a doorway, it was returned in the

opposite direction. When all had smoked the last man gave it to Little Plume. The latter, assisted by his wife, conveyed the heated stones from the fire on an extemporized long-handled spatula made of willow boughs. The first four stones were placed around the central depression and a fifth in the center. After Tearing Lodge had put a pinch of sweet grass on each to make incense, the four stones were pushed into the hollow, and other stones were brought in and heaped up. A bucket of water and a small round tin were brought into the house; we bathed our heads with the water and some drank of it. Finally, the entrance to the house was closed, the bucket was placed in front of Tearing Lodge, who ladled water on to the hot stove, and clouds of steam arose.

It was a novel sensation to be one of seven nude men squatting closely side by side in the dark, streaming with perspiration, and being continually parboiled by puffs of steam.

Tearing Lodge had been praying at intervals since he entered the sweat-house, but the prayers became continuous when the sweating began: again and again he put more water on the stones which further increased the temperature. Other Indians then prayed, and the heat became intense. After what seemed a long time a little fresh air was let in and cool water was given us to drink.

The orifice was closed again, the prayers were resumed and more water thrown on the stones. Once more the heat became almost insufferable, but relief could be had by holding the head low down, several of the Indians laying theirs on the ground. After all had prayed once more, air was again let in and I retired. Mr. Curtis and one Indian withdrew after the next round, and all the rest came out shortly afterward.

Mr. Curtis and I bathed in the adjacent stream according to Little Plume's advice, but the Indians sat in a practically nude condition in the open in order to cool off—praying all the while. The after effects of this bath were very pleasing.

Haddon's final remarks on the sweat—to the effect that it was "universal in North America"—while not strictly true (in that many peoples do not in fact practice it), tend to maintain the stress on its ordinariness. But he did add a comment that meshes well with other criteria for inclusion in *The North American Indian*, namely the religious dimension to the sweat: "Among the North American Indians the sweat-bath was usu-

ally—perhaps invariably—a ceremonial affair . . . employed to purify the spirit as well as the body, and if what I saw is characteristic there is no doubt that it is at the same time a devout religious exercise." But, then again, in Haddon's account there is always—as there is in the final comment just quoted—an underlying sense of Haddon's own presence ("Mr. Curtis and I were invited," "It was a novel sensation to be one of seven nude men," and so forth), an aspect of the project that was certainly played up for publicity purposes but was downplayed when it came to the contents of the published volumes of *The North American Indian*, where an apparently transparent "objectivity" was the aim.

Different Ways of Seeing

My final instance of the project's activities among plains peoples concerns Edmond S. Meany. Meany first rose to prominence as a newspaper reporter before becoming an institution at the University of Washington. He was a prolific writer, editor, and popularizer. He was a key supporter of the project, both in helping to "sell" it to potential patrons and in providing academic respectability and, on occasion, input. Curtis engaged Meany to write the "Historical Sketch" of the Teton Sioux for volume 3 of *The North American Indian* (1908). Mainly as a result of this commission, Meany accompanied the North American Indian party on the plains during the summer of 1907, and he helped gather data for both the project and his own extensive files. One of his financial accounts survives, detailing receipts ("From Curtis $5.00"), loans ("Loaned Myers $10.00 Got back $2.00 = $8.00," "Owe Upshaw $3.00"), and, most tellingly, expenditures ("Paid Red Cloud $4.00, Paid Walks in Sight $2.00"). He also sent reports back home for local publication in the *Seattle Sunday Times*. At Curtis's urging, he worked up one of these for the popular national magazine *World's Work*. This, from which an excerpt follows, was titled "Hunting Indians with a Camera" and was illustrated by a selection of Curtis's photographs.[21]

Catching glimpses of the inner life of the Indian is uncertain and often a dangerous occupation. Sudden caprice or unfounded suspicion may spoil the work of months.

The story of Mr. Curtis's visit to the Sioux of the Wounded Knee will give a little idea of the difficulties. Two years ago Mr. Curtis—or, as the Sioux call him, "Ba-zahola Wash-ti" [Pretty Butte]—made a long trip into the Bad Lands of South Dakota. His guide and leader was Chief Red Hawk. Mr. Curtis promised to return and give a feast to the chief and twenty of his followers on the banks of the Wounded Knee. Through the good fellowship growing out of the feast, Mr. Curtis hoped to secure photographs and records of many of the ancient Sioux customs. But Red Hawk found it impossible to restrict the invitations; instead of twenty, 300 gathered for the feast, and among them were chiefs equal in rank to Red Hawk. They felt that they must make their importance felt. Chief Slow Bull had brought his council teepee, decorated with buffalo-tails and with a horse's tail floating from the peak. It had come down to him from his father, and his father's father, with traditions of war-parties and the chase. Into this teepee Curtis was invited for a council. After his speech, Iron Crow, one of the chiefs, replied that to make all perfectly happy would take more beeves than Mr. Curtis had provided. He was reassured, and the council broke up with many "Hows" and much handshaking. But, as the first procession formed in the morning, Slow Bull raised his voice in that wild, matchless oratory of the Indian and brought the procession to a sudden halt. He, too, wished to be placated with more beef. Then a careless teamster nearly ruined the whole enterprise by throwing off one of the sugar-bags with the oats. After it had been rescued, the feast was finished without offense to anyone's dignity. Then, with true Indian caprice, they decided that they must rest and smoke for the rest of the day. Again the plan seemed on the verge of failure. Red Hawk had lost control.

Mr. Curtis quietly folded up his camera, as if he had not traveled many weary miles just to get these pictures. There was no fault-finding, no impatience; but, with infinite tact, he discussed affairs with some of the leading spirits. During the night a reaction in sentiment set in. In the morning the warriors, led by Red Hawk and Slow Bull, rode into camp. Their hearts were happy, they said, and they wished to help their white friend. Old rites were reenacted, old battles re-fought, old stories retold; and Mr. Curtis's pen and camera recorded it all.

Once again, the processes by which the data for *The North American Indian* was acquired were not mentioned in it. Volume 3, devoted to the

Sioux, does include some commentary on Red Hawk—whose picture also appears, both in portrait form and in other guises—but it does not mention these feasts, recreations of war and the chase, or even specially adorned council tipis. Also, there are disparities between Meany's earlier account for the newspaper and this magazine version. For example, in the newspaper account he informed readers that Red Hawk had been the subject of *An Oasis in the Bad Lands* (plate 90) and that the present feast was to be given "in return" specifically for a reproduction of "an old-time Sioux camp from which should be excluded all the new clothes obtained from the white people." He also provided a more detailed description of both the "scalp" on the council tipi—"It is in reality a horse's tail, but so arranged as to closely resemble the scalp from a woman's head"—and of the scene as a whole. Moreover, while the newspaper account did iterate difficulties over the beef provision, these were readily solved: "An adroit answer about a good feast and all being happy restored good feeling and then Big Road, the young chief of the Wounded Knee district, arose and made a fine speech about the respect for white men who did what they promised." Finally, in the newspaper version Meany emphasized the approval his own role as a spokesperson received when he concluded his remarks: "'Hows' and applause showed that [Red Hawk's people] entered into the spirit of the work."

I am not concerned to weigh the degree of truthfulness of these various versions of events. Rather, I want to point up the fact that from them subtly—or indeed baldly—different representations of both the project and the subject peoples emerge. The newspaper accounts, whatever their ultimate source, usually see the project as in pursuit of—to adopt the words of the *San Francisco Sunday Call* item—"weird customs." The unpublished memoirs, in their concern to present the intimate, previously undisclosed workings of the project, characteristically see it as intrepid, groundbreaking, and full of human curiosity, with the particular quotients of these qualities varying from project worker to project worker. Needless to say, perhaps, when project members produced such memoirs, even when the subject was ostensibly more Curtis than the actual writer, they were also constituting fragments of that writer's autobiography, with all the attendant subjective implications of such an act. In fact, in each of these accounts, there is an implied readership. That is

one of the reasons for adverting to Meany's *two* accounts of the project's visit to the Wounded Knee region: we see that his versions of the fieldworkers' activities for the readership of his own local newspaper and the national magazine differ.

In a lecture on "Indian Religion," Curtis said: "The average conception of the Indian is as a cruel, blood-reeking warrior, a vigorous huntsman, a magnificent, paint and feather bedecked specimen of primitive man. Of such we have no end of mental pictures, but to the wonderful inner and devotional life we are largely strangers."[22] Broadly, the newspaper and other early accounts stress what Curtis here dubs the "average conception," especially the unknowability of "Indians," their waywardness (for Meany it was "caprice") and recalcitrance (for Meany it was "suspicion"), whereas in *The North American Indian*, plains peoples are indeed noble, dignified, and religious. It is in the written and photographed images of *The North American Indian* itself that we are granted some sense of that "wonderful inner life." By the same token, whereas *The North American Indian*, with the exception of each volume's preface, in the main erases the presence of the fieldworkers and does not acknowledge the collaborative, large-scale nature of the project's operations, the project members' own accounts stress their presence and, beyond this, their resourcefulness, their powers of empathy, their fortitude, and above all, their heroism. Interestingly, Meany's *World's Work* piece even adds an almost gratuitous description of a storm, as if nature itself had to be overcome: "I have a keen recollection of our first camp among the Ogalallas. At dark a terrific storm struck the camp. The tent-poles broke and the tents flattened to the ground. Five Indian ponies in the neighborhood were killed by lightning."

In sum, the project, especially envisaged as a collective endeavor, does have something to say about plains cultures, but it is neither a straightforward record of them nor a monument to them, as Curtis himself claimed. And it is not—or not solely—a sentimentalized, nostalgic vision, as has been stated by Christopher Lyman and other commentators. Rather, it is a paradoxical representation: frequently beautiful or moving, sometimes puzzling, usually highly informative, and always interesting. As is so often the case, what we see depends upon the way we see it.

Notes

1. Edward S. Curtis, *The North American Indian*, ed. Frederick Webb Hodge, 20 vols. (Cambridge MA and Norwood MA: University Press and Plimpton Press, 1907–30). The quotation is from the preface to vol. 1. Curtis, "Indian Religion," unpublished typescript of a lecture, c. 1911, Karl Kernberger private collection. Curtis, "Vanishing Indian Types: The Tribes of the Northwest Plains," *Scribner's* 39 (1906): 657–71 (quotation, p. 657).

2. Information on Curtis and the project, based on research in primary materials, parallels extended discussion in Mick Gidley, *Edward S. Curtis and the North American Indian, Incorporated* (New York: Cambridge Univ. Press, 1998); all subsequent uncited data is taken from this source.

3. Letter, Curtis to F. W. Hodge, 28 October 1904 (emphasis added), Hodge Collection, Braun Research Library, Southwest Museum, Los Angeles; quoted in Gidley, *Curtis and the North American Indian*, 18.

4. *The Three Chiefs* was reproduced in "Did You Ever Try to Photograph an Indian?" *San Francisco Sunday Call*, 14 October 1900, clipping, Hodge Collection. Haddon, "Among the Blackfoot Indians of Montana," typescript in A. C. Haddon Papers, Cambridge University Library; a slightly abbreviated version appears in Gidley, "A. C. Haddon Joins Edward S. Curtis: An English Anthropologist among the Blackfeet, 1909," *Montana* 32 (autumn 1982): 20–33.

5. For Muhr, see Omaha city directories; Robert Bigart and Clarence Woodcock, "The Rinehart Photographs: A Portfolio," *Montana* 29 (autumn 1979): 24–37; and Bill Holm and George I. Quimby, *Edward S. Curtis in the Land of the War Canoes: A Pioneer Cinematographer in the Pacific Northwest* (Seattle: Univ. of Washington Press, 1980), 23–25.

6. The phrase "controlling logic of culture," appropriated from Umberto Eco, is deployed in Gidley, *Curtis and the North American Indian*, 13. William H. Truettner, ed., *The West as America* (Washington DC: Smithsonian Institution Press, 1990); see also Gidley, "Edward S. Curtis's Indian Photographs: A National Enterprise" in *Representing Others: White Views of Indigenous Peoples*, ed. Mick Gidley (Exeter UK: Univ. of Exeter Press, 1992), 103–19.

7. On Grinnell, see John F. Reiger, ed., *The Passing of the Great West: Selected Papers of George Bird Grinnell* (Norman: Univ. of Oklahoma Press, 1985). Curtis family lore may be found in Florence Curtis Graybill and Victor Boesen, *Edward Sheriff Curtis: Visions of a Vanishing Race* (New York: Thomas Crowell, 1976), 10–12. George Bird Grinnell, "Portraits of Indian Types," *Scribner's* 37 (March 1905): 259–73.

8. Quoted in Robert Doty, *Photo-Secession: Stieglitz and the Fine-Art Movement in Photography* (1960; reprint, New York: Dover, 1978), 24, emphasis added. For the Photo-Secession see also Weston J. Naef, *The Collection of Alfred Stieglitz* (New York: Viking, 1978). My other discussions of pictorialism and Curtis are

Gidley, "Pictorialist Elements in Edward S. Curtis's Representation of American Indians," *Yearbook of English Studies* 25 (1994): 18–92, and *Curtis and the North American Indian*, chap. 3. For earlier considerations, see Beth B. DeWall, "The Artistic Achievement of Edward Sheriff Curtis" (master's thesis, University of Cincinnati , 1980), especially chap. 3; Christopher M. Lyman, *The Vanishing Race and Other Illusions: Photographs of Indians by Edward S. Curtis* (Washington DC: Smithsonian Institution Press, 1982); A. D. Coleman, "Edward S. Curtis: The Photographer as Ethnologist," *Katalog* (Odense, Denmark) 5, no. 4 (June 1993): 25–34; and Paula Richardson Fleming and Judith Lynn Luskey, *Grand Endeavors of American Indian Photography* (Washington DC: Smithsonian Institution Press, 1993), 99–117.

9. Arnold Genthe, "A Critical Review of the Salon Pictures with a Few Words upon the Tendency of the Photographers," *Camera Craft* 2, no. 4 (February 1901): 310. Grinnell, "Portraits," 270.

10. For coverage of relevant racist ideology, see Thomas F. Gossett, *Race: The History of an Idea in America* (New York: Schocken, 1965), especially chaps. 10 and 13–16; Brian W. Dippie, *The Vanishing American Indian: White Attitudes and U.S. Indian Policy* (Middletown CT: Wesleyan Univ. Press, 1982); Gidley, "The Repeated Return of the Vanishing Indian" in *American Studies: Essays in Honour of Marcus Cunliffe*, ed. Brian Holden Reid and John White (London: Macmillan, 1991), 189–209. Curtis, unpublished script for the musicale, Kernberger collection. Curtis, "Plea . . . ," *American Museum Journal* 14, no. 4 (1914): 163–65.

11. Letter, William Henry Holmes to Curtis, 9 March 1905, E. S. Curtis file, Thomas Burke Papers, Manuscripts and Archives, University of Washington Libraries, Seattle.

12. Gertrude Metcalfe, "The Indian as Revealed in the Curtis Pictures," *Lewis and Clark Journal* [the journal of the Lewis and Clark Exposition, Portland, Oregon, 1904–5] 1, no. 5 (n.d.): 13–19, quotation from p. 13.

13. Gerald Vizenor, "Socioacupuncture: Mythic Reversals and the Striptease", in *The American Indian and the Problem of History*, ed. Calvin Martin (New York: Oxford Univ. Press, 1987), 186; Vizenor has returned to this broad topic, with passing reference to Curtis, in his *Fugitive Poses: Native American Scenes of Absence and Presence* (Lincoln: Univ. of Nebraska Press, 1998), especially chap. 4. Lucy R. Lippard, ed., *Partial Recall* (New York: New Press, 1992); Tim Johnson, ed., *Spirit Capture* (Washington DC: Smithsonian Institution Press, 1998); and Jane Alison, ed., *Native Nations: Journeys in American Photography* (London: Booth-Clibborn Editions for Barbican Art Gallery, 1998). George Horse Capture, foreword to *Native Nations: First Americans as Seen by Edward S. Curtis*, ed. Christopher Cardozo (Boston: Little, Brown, 1993), 13–17. It is to be hoped that the proceedings of "Edward S. Curtis and *The North American Indian* Reviewed," the Smithsonian Curtis symposium, will eventually be published. Gidley, *Curtis and the North American Indian*, 283.

14. Richard Brilliant, *Portraiture* (London: Reaktion, 1991), 106–7.

15. See Lyman, *The Vanishing Race*, 106–7. The restaged battle images fed into the iconography of the western as refined by John Ford and others.

16. W. W. Phillips, "With the Cheyennes," typescript in private collection (photocopy in author's collection); subsequent quotations from this script. At another point in the memoir Phillips outlined more deliberate means of acquiring material: "To secure data relative to medicine practices or ceremonial rites from new tribes, without undue delay, forces one to resort to many stratagems. I find that relating stories of foreign tribes to members of one under study, proves a good method of drawing them out, though by no means successful at all times. Another way is to exhibit photographs of striking scenes and types of some foreign tribe to a local tribe; it does more to arouse interest and curiosity in the average Indian than endless explanations, or pounds of sugar and tobacco possibly could."

17. Harold P. Curtis, interview by author, Port Townsend WA, January 1977; see also Homer H. Boelter, with Lonnie Hull, *Edward Sheriff Curtis: Photographer-Historian* (Los Angeles: Westerners Brandbook, Los Angeles Corral, 1966), n.p.

18. *San Francisco Sunday Call* item cited in n. 4 above. Curtis, *North American Indian*, 6 (1911): 31–58. Curtis, "Vanishing Indian Types," 663.

19. John Stands in Timber and Margot Liberty, *Cheyenne Memories*, 2d ed. (New Haven: Yale Univ. Press, 1998), includes several comparable instances of Cheyenne medicine.

20. For sources of Haddon's reminiscence and contextualization, see n. 4 above; subsequent quotations are from this typescript. See Curtis, *North American Indian*, 6:66–67.

21. For Meany, see the biographical sketch in Gidley, *Kopet: A Documentary Narrative of Chief Joseph's Last Years* (Seattle: Univ. of Washington Press, 1981), 8–10. His financial account found among the uncatalogued portion of the Edmond S. Meany Papers, Manuscripts and Archives, University of Washington Libraries. Meany, *Seattle Sunday Times*, newspaper item of 11 August 1907, taken from an advertising brochure for *The North American Indian*, c. 1910, author's collection. Meany, "Hunting Indians with a Camera," *World's Work* 15 (March 1908): 10004–11; subsequent quotations are from this article.

22. Curtis, "Indian Religion" (cited in n. 1).

The Aesthetic Impulses of Edward S. Curtis's Images of the Great Plains Indians

Duane Niatum

The focus of this chapter is Edward S. Curtis's aesthetic impulse and the ways he used the camera to accomplish his artistic ambitions. Of paramount importance to Curtis's photographic work was his belief, shared with his generation, that the North American Indians were a vanishing race. His work thus became a documentary artistically rendered through the photographic medium. Yet Curtis's aesthetic impulse concentrated on the artistic needs of his image to the degree that any usefulness the image had as ethnographic fact or historical reference was compromised, sometimes totally. Curtis wanted his viewer to experience his images as beautifully composed works of art. Nonetheless, he took enough photographs that served both ethnographic and historical purposes that, in the end, it really does not matter that it was never his primary interest. He resisted at every opportunity the stereotyped and boxed-in role of a mere ethnographer who happened to do most of his fieldwork using a camera. Yet no one today questions the fact that he is considered to be the most influential photographer of North American Indians in our history.

As our society says good-bye to another century and reflects on our

past, we find that some of the issues troubling us are similar to the issues that troubled Curtis's generation. As a young nation without definite roots we lack a solid identity as a nation and a people. Part of the problem in resolving this identity crisis stems from the uneasy realization that the nation and the people have never adequately come to grips with their relationship to the American Indian. This issue remains as emotionally charged for us as it was for the people during colonial times. The relationship continues to be touchy and ambivalent in many areas such as politics, education, land and water rights, and economics. These types of conflicts appear in the news almost daily. Curtis and others involved in recording the lives and cultures of the American Indians were convinced that time was running out and that those interested in helping them preserve what they could of what was still intact had better act fast. Curtis took up the challenge. As a result of his many travels into Indian country across the nation over the decades, the Indians started calling Curtis a "Shadow Catcher." However, as Laurie Lawlor, one of Curtis's biographers, suggests, the images Curtis took are a good deal more than shadows. The men and women and children appear as alive today as on the day Curtis took their photographs.

Curtis followed his intuition and learned that the essence of a people is best found in the spiritual depths of their souls. His purpose was to share this revelation and thus give future generations the chance to better understand and relate to North American Indians. Curtis envisioned his project from its inception as one for the general public as much as for the scholar. As he said, the work was "transcriptions for future generations that they might behold the Indian as nearly as possible."[1] Curtis's contribution is staggering: 40,000 photographs, 350 myths and legends, and 10,000 recordings of music and speech in 75 different languages.[2] Curtis and many of his generation believed that without this knowledge available, the social and cultural vacuum in the relationship between Indian and white societies would continue. Furthermore, Curtis hoped his project would challenge the ideas of many homesteaders on the plains who favored Colonel M. Shivington's solution to the "Indian problem." Shivington told his troops before entering battle with the Indians to "Kill and scalp, big and little, nits make lice." This attitude as the national sentiment made it easier for U.S. army troops during a few hours

on 29 November 1864 to massacre three hundred innocent Cheyennes and Arapahos at Sand Creek, Colorado. Nearly three-quarters of the dead were women and children.[3]

There was also the no-nonsense journalist Horace Greeley, who declared in the 1870s that "these people must die out—there is no help for them." Like most Americans at the time, Greeley believed in his self-righteous way that it was America's destiny and duty to civilize or subdue "these red savages" from coast to coast.[4]

The idea of the vanishing Indian existed even before Curtis was born. Justice Joseph Story is quoted as saying in 1828: "By a law of their nature, they seem destined to a slow, but sure extinction. . . . [T]hey pass mournfully by us, and they return no more."[5] Similar statements were made throughout the nineteenth century as the Indians lost their lands and their cultures were either eroded or destroyed. In Curtis's view, his job was to survey the old ways of all the major tribes west of the Mississippi River.

Sources that Inform a Shadow Catcher's Art

Curtis began to take photographs of Indians in and around the Puget Sound region in the mid-1890s, several years before he chose to commit to his life's work, the monumental *North American Indian*.[6] Curtis's experience as a witness to the sun dance gathering of Blackfoot, Bloods, and Algonquins on the Piegan reservation in Montana in 1900 acted as a catalyst for his later work. He was invited to the gathering by George Bird Grinnell. From a high mountain cliff near the Canadian border, the two could see below a circle of tipis nearly a mile wide. Thousands of Indians were there to celebrate the sun dance, a complex of ritual and prayer that would give strength to both individual and tribe. Grinnell told Curtis to appreciate the sight because he doubted there would ever be that number of Indians in one place again. Grinnell was no prophet, but it was the last gathering of that number of Indians in North America. Curtis was completely awed by the scene and said later in reference to the experience that "it was the start of my effort to learn about the Plains Indians and to photograph their lives."[7]

It is known that "the dates of Curtis' images are often uncertain, since

records are either sketchy or nonexistent. Where dates are known or may be approximated, they are included to indicate the date somewhat after the image would have been made."[8] However, we know that Curtis's project nearly coincides with the pictorial movement (1889–1923) and that this movement influenced his work. Curtis published the last volume of his magnum opus, *The North American Indian*, in 1930.

Curtis was an astute student of the pictorial movement in both art and photography. He learned a great deal from the pictorialists about style and technique. They stressed the personal and the expressive and were convinced that photographers learn their art best from painters and other visual artists. In aesthetic terms, this meant the quest for beauty and the right emotion was essential for the photograph to come alive for the viewer. Thus, artist-photographers adopted the subjects and themes of painters, such as rural life, formal portraits, landscapes, nudes, fantasies, allegories, and genre scenes. They also believed that a sense of the artful and picturesque should resonate from the image.[9] Curtis quickly absorbed these values and applied them to his own style.

A technique Curtis applied to his own art was to place the central figure of the image in the lower portion of the picture and to align the figure's head with the horizon. A painter from an earlier period who could have taught him this technique very well was Jean-François Millet (1814–75), but there were other Europeans and several American painters who may have shown him this technique.

Style was a value that Curtis introduced to his images early in his career. His images are not simply fashionable but are distinct and expressive in composition and design. Moreover, he wanted the images to mirror his inner nature and emotional frame of reference as much as those of his sitter. Like most pictorialists, Curtis worked hard at getting his images to suggest an atmosphere and play of light and shadow that was expressive of the impressionists. Exactness of pose was expressive as well. In the best pictorial tradition, his images were perfectly balanced and all the elements harmoniously arranged so the subject matter could appeal to the senses as much as one's mind, while the quest for beauty remained the ultimate goal.[10] This quest for beauty was asserted by most artists during the period, no matter what the medium, and it helped pictorial photographers build a solid bridge between art and life.[11]

The common view of photography in the 1840s, as expressed by the photographer Albert Bisbee, was that unlike painting, photography presented things "as they actually are. . . . The objects themselves are, in one sense, their own delineators, and perfect accuracy and truth the result."[12] This view proved too narrow a definition, as photography began to deal with both social issues and aesthetic values. An expanded view then emerged. By 1896 photographer H. P. Robinson, borrowing from the French novelist Émile Zola to support his position, stated that "Even a photograph is a piece of nature seen through the medium of a temperament."[13] Still, an anonymous critic writing in the *Photographic Art-Journal* said, "The fact is, the people care nothing for what they do not understand. They do not value pictures as mere pictures. . . . It is the subject of the work which fixes their attention; the character and feeling and passion expressed."[14]

It was Curtis's generation of pictorial photographers that reacted to what they perceived as the dehumanizing effects of science and applied technology on our culture. Therefore, they sought to move photography away from these influences. Although this was part of their mission, the images created during the nineteenth century were expected to translate the externals of life into a visual form as a method of preserving it as well. Thus, "emphasis was on recording the salient points of an object or its principal characteristics so the photograph would serve as an aid to memory."[15] Yet by the end of the nineteenth century, this view was almost completely usurped by the value placed on the subjective self's search for what was meaningful and beautiful in the real world. The artist-photographer argued passionately and tirelessly that a photograph could reflect the character of the photographer in the same way a painting could its painter, and that the photograph could interpret and reveal reality while simultaneously revealing the inner nature of the artist-photographer. The artist-photographers inscribed their personal impressions on the object, which became the signature of the entire modernist movement in every media. Pictorialism, therefore, established the path for modern photography.

The pictorialists based their efforts on the established canons of art, from the Renaissance classicists Leonardo da Vinci and Michelangelo, to the seventeenth-century realist Dutch painters, and on to the nine-

teenth-century impressionists. They even studied and emulated the British painters, particularly Constable and Turner. Artist-photographers believed the most eloquent aesthetic was found in the work of these mentors, whose work embodied their idea of "truth to nature." They understood that before photography could explore new paths and advance its position, it needed to come to terms with what one perceived as reality. As pictorial photographers, they assumed that if they found the truth of nature they would automatically find the beauty of nature too. However, they advocated that one not become a slave to nature and simply imitate her. Instead, artists had to be selective of what they were observing and endeavor to compose the elements into a coherent whole in such a way that a new vision of person, place, or things is revealed.

Eventually pictorial photographers decided that the only real requirement was "the individuality of interpretation and the necessity of good taste." Furthermore, they developed a rigorous and unified aesthetic that mirrored "a new vocabulary and a rising standard of taste."[16] Today we recognize that those values and that aesthetic reflect in many ways the taste and aspirations of an increasingly middle-class society.

It was during this period that the negative and print became distinct. For artist-photographers the negative showed the subject closest to nature, while the print became the work of art. This development may be the most revolutionary one during the period, more than any single earlier invention.[17] These artists strengthened their position in the eyes of critic and viewer by stressing softness of tone, contrast, and focus, which allowed them to produce dreamy, romantic, and evocative images. Curtis introduced these values into his own work on several occasions. Alfred Stieglitz was the photographer who led the movement that transformed the craft of photography into art. Stieglitz became the most successful spokesperson for photography as an art, and he won many skeptics to his way of thinking. Not only was he a highly gifted artist of the camera, he articulated his ideas on the subject in a persuasive manner. He convinced the world that photography was helping human vision advance into new realms of seeing, thinking, and feeling.

The artist-photographer George Davison claimed that he and his generation found the beauty of pictures best when they captured "their truth to nature."[18] Davison and his generation agreed with the original "prin-

ciple that photographs were the embodiment of a subjective intelligence and that if their pictures had a purpose, then it was not simply to show but to reveal the truth beneath appearances." Davison pointed out that "photography is not limited to, nor compelled to emphasize, facts of form. It gives form by means of tone against tone, and that is the best means of rendering it." Davison offered another important idea when he said that "the keenest aesthetic pleasure is to be derived from the spirited truthful rendering of character, whether in face, figure, or landscape."[19] With photography's rapid development, Estelle Jussim tells us, it largely displaced painting by the end of the 1890s as illustrations of facts. She says that "photography supplied, for the first time, a visual measure of authenticity; and it was by this standard that statement of fact began to be judged." So, very quickly, "it was expected that statements of fact would be made *only* by photography, and not by artists. Therefore, we see a literal diminishing of the role of the illustrator as a 'packager of information.' " One result of this shift of view is "that we no longer trust noncontemporaneous or noncamera images."[20] The passing on of one's personal experience was a method of particular importance to artist-photographers because photography had no academic institutions or standing, and formal training in the field did not yet exist; therefore, they were left with the need to learn most of the ins and outs of their art on their own, from magazines and journals, or from fellow photographers.

Dr. Peter Henry Emerson, an English physician, published *Naturalistic Photography* in 1889, which became a mainstay for those photographers working as artists within this media.[21] The publication coincided with Curtis's decision to move to Seattle with the intent of working as a professional photographer. The decade of the 1890s became a period of earnest pursuit, both in Europe and America, of the acceptance of photography as a legitimate and unique art form. Photographers sought support and inspiration from one another and strove to establish aesthetic principles and critical views based upon the work itself. Thus, Curtis adopted the views espoused by Emerson that had resonance for him. Peter Pollock in his introduction to *Naturalistic Photography* succinctly grasps those ideas expressed by Emerson that were to influence Curtis's work. The first was that "the eye sees most sharply in the center of the field of vision, whereas objects perceived by the periphery of the eye are

progressively less defined." And the second view was that "nothing in nature has a sharp outline."

The aesthetic values that Dr. Emerson offered students of art photography were the values that Curtis adopted as his own: (1) be extremely selective in one's choices of subject matter, (2) keep focused on what the basic elements of the composition are, so one clearly recognizes which elements deserve the most emphasis and which should be relegated to secondary positions, (3) exercise much thought and reflection upon tone quality, as atmosphere helps greatly in making the image come alive and seem close to nature, and (4) pay close attention to what might be extraneous to the overall composition and cut those parts from the picture so that one's original vision shines through. Furthermore, Dr. Emerson took a famous picture in 1886 that Curtis surely knew and admired, his *Gathering Water Lilies*. Curtis did several photographs of Klamath Indians among the marshes surrounding Klamath Lake in southern Oregon in which they were gathering water lilies (*wokas*), which they once used as a staple food.[22]

After studying specific images of Curtis's work, one discovers that he was far more committed to the aspirations of art photography than he ever was to the needs and requirements of ethnography and history. In fact, aesthetic considerations almost always determined his approach to a particular subject or theme and how he framed that subject to fit his particular view. He was known to be meticulous and demanding of himself that the image's design pattern should appear harmonious and totally integrated. The idea of wholeness relates to another quality he admired and wanted his image to express to his viewer—the idea of symmetry as the unifying force behind his composition and design patterns. Even as early as the 1890s, what must have struck the critic and public about his photographs was how he used a technique of adding an emulsion of gold or silver to coat the photographic plate, which enhanced the dramatic quality of the picture. A sense of the dramatic and a suggestion of heightened intensity became qualities integral to Curtis's style.

During the period Curtis took his photographs, he was by no means the only person taking photographs of the American West. Other noteworthy photographers were Carleton Watkins, William Henry Jackson, Timothy O'Sullivan, and Edward Muybridge. However, no one spent as

much time living and working among the various western and Alaskan Natives as Curtis.[23]

Adolf F. Muhr, Curtis's studio assistant in Seattle, thought Curtis was successful in his thirty-year project because he was able to win the Indians' trust in what he was doing and because he always displayed tact, diplomacy, courage, patience, and perseverance. It is now known that many white researchers who went into the field failed because they lacked these qualities. Curtis may have achieved what he did because the Indians sensed that he genuinely admired them. Curtis was well aware that "Indians instinctively know whether you like them or if you're patronizing them."[24]

As a portrait photographer, Curtis was interested in presenting not only the physical appearance of his sitters but the personality and the character beneath their appearance. Furthermore, Curtis followed a cardinal rule that most white researchers in the past did not. He waited patiently for them to invite him to participate in their ceremonies. In this respect, Curtis was always a gracious guest. His photographs that have withstood the test of time show us how successful he was in his enterprise.

With the image of Black Eagle, an Assiniboine (1908; plate 61), Curtis has it both ways. He is artist and ethnographer. The powerfulness of this warrior chief is evident in his expression, which informs the viewer that his name tells us what kind of person he is in and out of battle. But the use of chiaroscuro—modeling the illusion of the volume, and mass of natural objects by light and dark gradations, usually in smooth transitions called continuous halftones—adds to the mysterious sense we have of the chief and also tends to enhance this quality of his character by drawing the viewer up close to the face of Black Eagle. His face assures us that he has earned the respect and honor of both his community and that of his enemies. The portrait of Black Eagle shows how much the Indians had grown to value Curtis's work as his reputation preceded him into Indian country. Long before the photograph was taken, Black Eagle told his people that Curtis was not going to be allowed to enter any Assiniboine camps. However, Black Eagle had a change of heart when he discovered for himself that Curtis was not a trickster. In fact, Black Eagle approached Curtis's tent and asked the artist to take his photo-

graph. This was an act of faith. This event is a credit to Curtis as artist and ethnographer and to Black Eagle as a warrior and a human being. Curtis believed his success lay in his open desire to know these people. Curtis is quoted as having said, "[W]e, not you. I never worked at them. I worked with them." An elder Lakota man once said, "He is just like us. He knows about the Great Mystery."[25]

Curtis always maintained that the major purpose of his work with Indians was to photograph them in their traditional clothing and dress. He wanted, above all, to capture the old ways before they were lost. Photographing a certain young Lakota woman (*Sioux Girl*, 1907; plate 12) thus must have been a pleasure for him. She is dressed completely in the traditional manner of her people. The design elements of purse, dress, and moccasins are traditional Lakota. The evidence to support this claim is found in the various symbolic emblems or design patterns of her dress and accessories. Although girls and women from every plains tribe had similar dresses, leggings, moccasins, and purses, what makes this girl's clothing identifiable as culturally specific are the symbols found on them. Each tribe created its own symbols and design patterns for these items. Curtis may not have been interested in going this far with his identification, but if he had, it would have offered much more knowledge to his viewer.

This image is a good example of an occasion when Curtis, despite his "box of props" reputation, played the role of ethnographer willingly and successfully. Here, all the elaborate design elements are clearly displayed and sharply defined. The girl's deerskin dress presented in this manner tells about her people's customs and tastes. What the people wore demonstrated what they valued not only aesthetically but socially and often politically as well. Thus, clothing and accessories spoke volumes about what the people thought was beautiful and pleasing to the eye and to the rest of the senses. They even believed it would enhance the individual's spirit. The beads she wears are trade beads, which tells us she came from a wealthy family. Porcupine quills reveal the work was made in a traditional manner, since porcupine quills are no longer in use.

In the photograph *Waiting in the Forest—Cheyenne*, 1910 (plate 24), Curtis attempts to show the unknown quality of the American Indian, a quality that whites were continuously puzzled about. Who the Indians

really were remained a mystery to them. We do not know if Curtis was actually trying to suggest this mystery, but one of the requirements of the romantic movement of the nineteenth century was to seek the mysterious in nature and in the everyday world. The romantics believed that the mystery of life and the universe was one element that would set the work apart and spark the viewer's curiosity and emotions. Curtis suggests this quality in a simple arrangement of a young man waiting for his love in the forest. Because the Great Plains Indians lived in constant and close proximity to family members and others, it was difficult for lovers to find a retreat where they could just be with one another. The Cheyennes and other plains tribes diffused the tension by establishing the convention whereby the lovers could be alone in the forest. The right to privacy of the lovers outside the domain of the camp was strictly enforced. The woman could even hide within the robe of her sweetheart and both could remain anonymous. This fact does a splendid job of countering the whites' stereotype of Indians' having no individuality and always sacrificing their personal needs for the tribe. Individuality *was* given a place in the community, and privacy, though often difficult to achieve, was valued. Here one witnesses individuality in communal life—a separate space. The viewer might be excluded from the subject, but it is not a hostile gesture. Rather, it speaks only for the right of privacy, and because of this the viewer does not mind.

By taking his photograph around dusk, an aura of mystery is at work in the composition. Keeping most of the background in the dark dramatizes the man's robe. The tension builds subtly in the simple act of waiting. As Tom Beck suggests, the figure almost seems to float in a black space.[26]

The image of a Piegan camp (*At the Water's Edge—Piegan*, 1910; plate 73) further demonstrates how thoroughly Curtis has mastered the aesthetic values of the pictorialist movement. Every aspect of the composition, all the design elements and formal patterns, reflect this sophistication. The play between the triangular shapes of the tipis that are mirrored in the water and the way in which the land edges out into the water in triangular shapes are all different elements in the composition that unify the patterns of the image into a unique whole. Yet the design elements on the tipis actually reinforce the image's overall composition re-

quirements. Curtis had to move his camera back from the camp to establish the effects he was after, so clothing details that would augment the ethnographic content are lost. Except for the art designs on the tipis, ethnographic information is ignored for the aesthetic impulse to give pleasure to the viewer. Curtis took another path and responded to the Muse's request to highlight the quest for beauty. Therefore, the play of shapes heightens our sense of joy, and this is what makes the image special and a perfect example of the charm that can create art from life.

Curtis, throughout his long journey into Indian country, always made it a practice to study his subjects thoroughly before taking their pictures. He wanted to learn, in person, as much as he could about them and the role they played in their society. He would often have long talks with his sitters before taking any pictures. He presented them in their traditional setting as much as was possible under the pressures of the ever-changing circumstances in the American landscape and society. He consulted everyone he could who might be able to add some information about his sitter's biography. Each member of the family and each friend was consulted.

The most amazing thing about his photograph of Hollow Horn Bear (1907; plate 4) is the fact that he was a warrior who had a reputation of mythic proportions; pride and fierceness played key roles. Yet in this picture of the warrior chief, there is no pride or fierceness. The artist-photographer has performed a miracle. The viewer sees a gentle and kind side to this man's nature. Such skill is what truly reveals Curtis's genius; somehow, he got this man to drop his guard and mask. It is as if Hollow Horn Bear were saying directly to the viewer, "Forget the stories you have heard of my glories in battle and the hunt, my physical prowess and fierce nature. Trust me, my friends, that is all a show. The man you see looking into your eyes with nothing but the feeling of peace and friendship flowing through the river of his mind is the real me. I am only a small creature of the earth and not ashamed of the fact."

Curtis photographed Chief Red Cloud on the Pine Ridge Reservation in 1905 (plate 13). Red Cloud was blind and almost deaf when Curtis took his picture. It was forty years after Red Cloud had fought his most decisive battle with white soldiers in 1868, the year of Curtis's birth. Lawlor mentions how remarkable was Red Cloud's courage and tenacity

in the face of betrayal. None of the promises made to Red Cloud were kept; every one of them was broken. Yet even with horrendous betrayal, poverty, and abandonment, Red Cloud's face never hints at these things. This is a credit to Curtis as a portrait photographer. The image shows he was interested in preserving not only the physical appearance of his sitter but the personality and inner character as well. One does not see a broken or beaten-down Plains Indian warrior, or a man whose features look like those of a crippled horse. One does see the portrait of an elder chief who won many battles with his enemies, who promised him and his people land and freedom and supplies if he would lay down his arms. The viewer does not see the pain and insult of betrayal nor the greater pain of being held to blame by his people for the disastrous aftermath wrought by the failed treaties. What one sees is an elder man, probably blind yet looking strong and composed with a dignity that defies his years. Moreover, it is the face of a man who never gave up. In a way, we can say that Red Cloud's portrait reflects Curtis's own inner nature and tenacity as well. Curtis never abandoned his Indian project and often continued working on it when everything was set against him doing so.

Edward S. Curtis interpreted the society and place of the Great Plains Indians within the context of the conflict between humanity and nature. Curtis and his generation saw the Indians as a direct link to nature and knew, perhaps only intuitively, that the destruction of their culture and lands reflected the destruction of the natural world. He had undoubtedly read Henry David Thoreau's claim that "In wildness is the preservation of the world," as his photographs and writings act upon that idea.

Curtis's aesthetic impulse was inspired by his generation's belief that the Indians were doomed to become a vanishing race. He believed that only through education would there develop a better relationship between Indians and whites. Curtis was determined to survey the old ways of all the major tribes west of the Mississippi River, and he committed himself to this lifetime endeavor. His project focused on the preservation of Indian culture through the photographic medium as well as the recording of music, story, and speech.

During Curtis's long career of photographing Indians and the Ameri-

can West, other photographers also worked to capture the same subjects. Yet, as we have noted, none of the other photographers spent as much time at it as Curtis. He won the trust and respect of the Indians he photographed, enabling him to achieve his larger goal of presenting the character of the individual that lay just beneath the surface. However, an overview of Curtis's life's work shows that aesthetic needs always took precedence over the needs of history and ethnography. Indeed, a sharp eye for aesthetic needs was the basis of Curtis's style. The placement of the central figure in the lower portion of the frame, aligning the figure's head to the horizon, became one of his important stylistic choices. The result was a thoroughly composed design that revealed a distinct and expressive image. Moreover, Curtis wanted to show that photography as an artistic medium could reveal the character of the photographer as much as a painting could its painter, and that the inner nature of the photographer could be expressed as much as the outer reality. He was determined to create a new set of values and vocabulary that spoke specifically of his own efforts; the photographer might be seen as a part of nature witnessed through the medium of an image, those images being various American Indians. Curtis and his work, his art, and his particular perspective on the American Indian have endured, and his images engage us today as much as they did when the public first saw them.

Notes

1. Laurie Lawlor, *Shadow Catcher: The Life and Work of Edward S. Curtis* (New York: Walker, 1995), 5.

2. Lawlor, *Shadow Catcher*, 3, 5.

3. Lawlor, *Shadow Catcher*, 13.

4. Lawlor, *Shadow Catcher*, 13.

5. Tom Beck, *The Art of Edward S. Curtis: Photographs from the North American Indian* (Edison NJ: Chartwell Books, 1995), 13.

6. Beck, *Art of Edward S. Curtis*, 13.

7. Curtis was probably aware of the great work produced by such painters as George Catlin, John Mix Stanley, and Karl Bodmer among the various North American Indian tribes and knew that their goals were quite similar to his, especially in their desire to present the Indian in his or her native context.

8. Beck, *Art of Edward S. Curtis*, 23.

9. Beck, *Art of Edward S. Curtis*, 8.

10. Beck, *Art of Edward S. Curtis*, 11.

11. Peter C. Bunnell, ed., *A Photographic Vision: Pictorial Photography, 1889–1923* (Salt Lake City: Peregrin Smith, 1980), 2–3.

12. Bunnell, *Photographic Vision*, 1.

13. Bunnell, *Photographic Vision*, 1.

14. Mary Panzer, *Matthew Brady and the Image of History*. (Washington DC: Smithsonian Institution Press, 1997), 75.

15. Bunnell, *Photographic Vision*, 1.

16. Bunnell, *Photographic Vision*, 3.

17. Bunnell, *Photographic Vision*, 4.

18. Bunnell, *Photographic Vision*, 13.

19. Bunnell, *Photographic Vision*, 7, 18–20.

20. Estelle Jussim, *Visual Communication and the Graphic Arts: Photographic Technologies in the Nineteenth Century* (New York: R. R. Bowker, 1993), 201, 211.

21. Peter Henry Emerson, *Naturalistic Photography* (London, 1889; New York, 1890; reprint, New York: Amphoto, Inc., 1972).

22. Beck, *Art of Edward S. Curtis*, 102.

23. *Encyclopedia Americana*, international ed., 1999, s.v. "The Golden Age of Photography."

24. Lawlor, *Shadow Catcher*, 65.

25. Lawlor, *Shadow Catcher*, 5.

26. Beck, *Art of Edward S. Curtis*, 72.

The Plains Indian Photographs
of Edward S. Curtis

Note on the Captions

Please note that captions for most of the photogravures consist of Curtis's extended captions from the "List of Plates" that accompanied each portfolio (indicated by roman numeral) followed by plate number (indicated by arabic numeral). These captions sometimes refer the viewer to biographical sketches or other passages in the volumes of text (which are indicated by arabic numerals and page numbers). Because some of Curtis's extended captions and sections of text are quite lengthy, a number have been quoted in part.

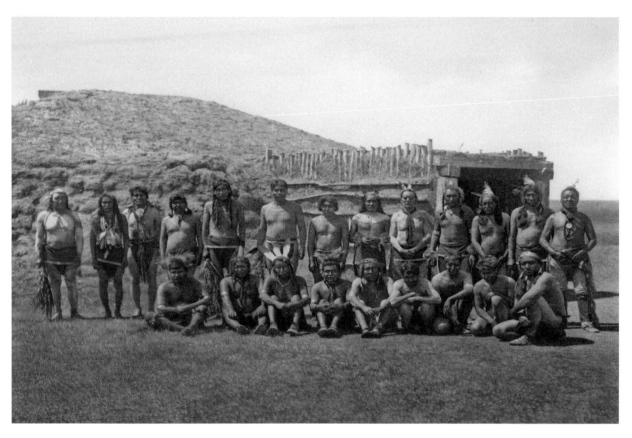

1. Arikara Medicine Fraternity
©1908 (v, 157)

"In this group are shown the principal
participants in reenactment of the Arikara
medicine ceremony, which was given for
the author's observation and study in July,
1908."

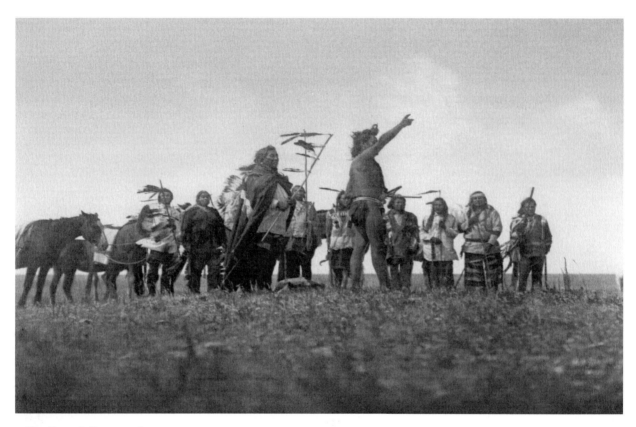

2. The Scout's Report—Atsina
©1908 (v, 182)

"The chief of the scouts returning to the
main party, tells in vigorous and
picturesque language so natural to the
Indians what he has seen and experienced.
While he speaks, the war-leader stands
slightly in advance of his men, and
carefully listening to the words of the
scout, quickly forms his plan of action."

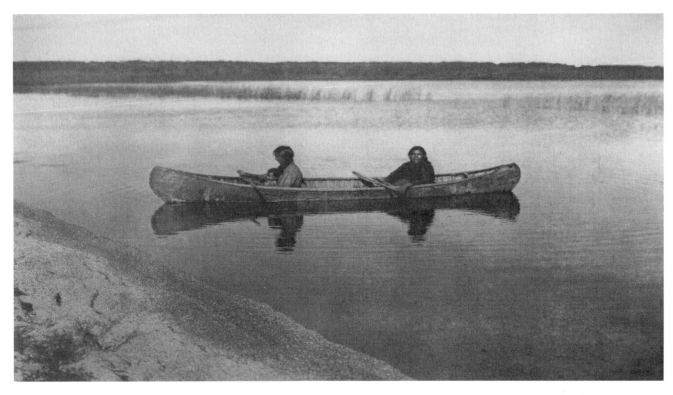

3. A Cree Canoe on Lac Les Isles
©1926 (XVIII, 621)

"The Western Woods Cree, Bush Cree, Swampy Cree, or Maskegan . . . are scattered in numerous bands through wooded country north of the prairies between Hudson bay and the Peace river drainage. Other members of this large family inhabit the plains of Manitoba, Saskatchewan, and Alberta and the country from Lake Winnipeg to Lakes Mistassini and Nitchequon in the Province of Quebec. . . . Lac Les Isles, locally known as Big Island lake is in west-central Saskatchewan, near the Alberta border. The canoe is a well made craft of birch bark."

4. HOLLOW HORN BEAR
 ©1907 (III, 82)

"Brulé. Born 1850. First war-party at
twelve, against the Pawnee. At nineteen
he . . . led a party which killed a number of
Pawnee wood-haulers. Struck a first coup
. . . in that battle. . . . During his career as
a warrior he counted coup many times and
participated in twenty-three fights with
Pawnee, Omaha, Ponca, Shoshoni, Ute,
Arikara, and United States troops. He was
present at the Custer fight." (volume 3, p.
186)

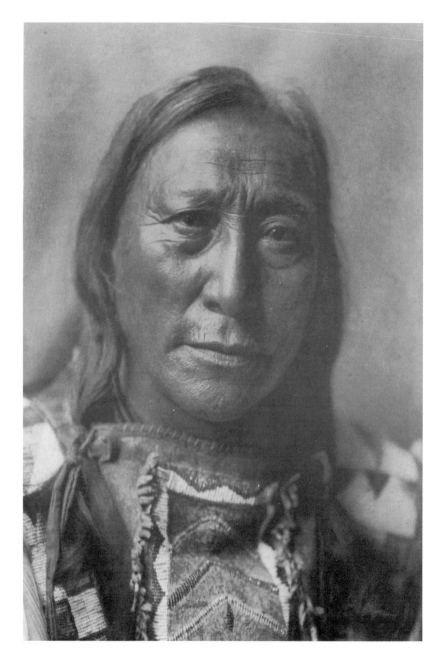

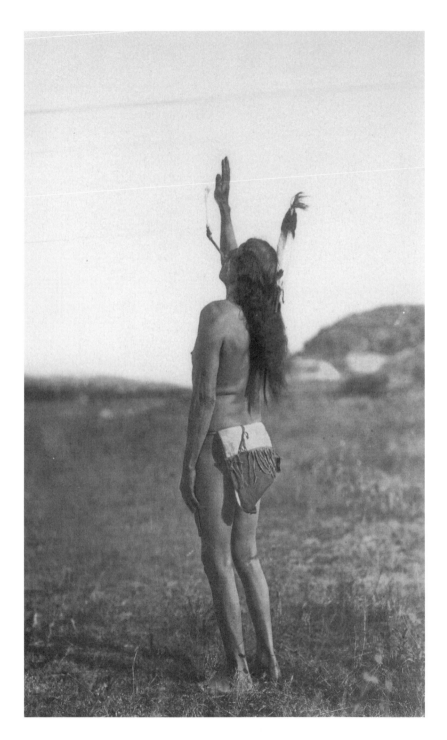

5. THE SUN DANCER
©1907 (III, 83)

"As they dance, the performers never
leave the spot on which they stand, the
movement consisting in a slight upward
spring from the toes and ball of the foot;
legs and body are rigid. Always the right
palm is extended to the yellow glaring sun,
and their eyes fixed on its lower rim. The
dancer concentrates his mind, his very self
upon one thing he desires, whether it be
achievement of powerful medicine or only
success in the next conflict with the
enemy."

6. HIGH HAWK
©1907 (III, 87)

"The subject is shown in all the finery of a
warrior dressed for a gala occasion—scalp
shirt, leggings, moccasins, and pipe bag, all
embroidered with porcupine quills, eagle
feather war bonnet, and stone headed war-
club from the handle of which dangles a
scalp. High Hawk is prominent among the
Brulés mainly because he is now their
leading historical authority, being much in
demand to determine the dates of events
important to his fellow tribesmen. His
calendar or 'winter count,' is explained
and in part reproduced in Volume [3], pp.
159–82."

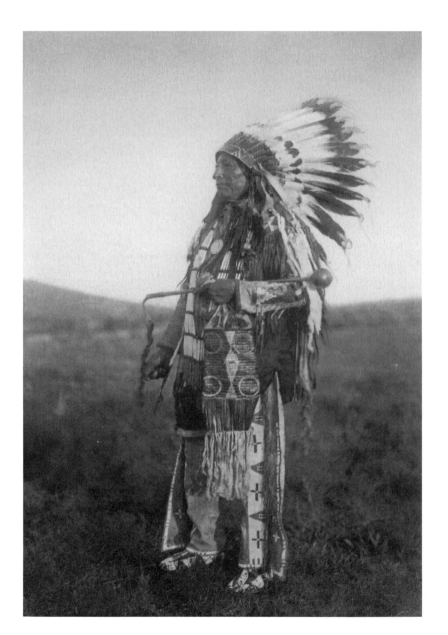

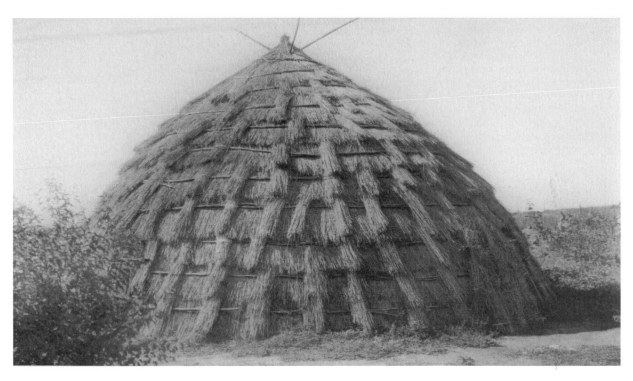

7. WICHITA GRASS-HOUSE
©1926 (XIX, 654)

"The relatively permanent character of the typical dwelling of the Wichita indicates the sedentary life of this tribe. They were farmers in the main, but hunted the buffalo and other game in season."

"The family grass-house was from 18 to 30 feet in diameter. The exact location of the openings was prescribed in the spirit instructions for the building of the ceremonial lodge and the same formula was followed strictly in building a family dwelling. The beds, four to twelve or more . . . were raised a few feet above the ground and each consisted of four crotched posts which supported a light frame of poles upon which was lashed a covering of buffalo-hide." (volume 19, p. 38)

8. Old Eagle—Oto
©1927 (xix, 679)

"The headdress of this Oto is
characteristic of the older style, like that
worn by the related Osage in plate 680
and the adopted headdress of Comanche
. . . . The medal worn by Old Eagle, in this
case bearing the portrait of Lincoln, is like
other medals given by the Government to
noted chiefs from Washington."

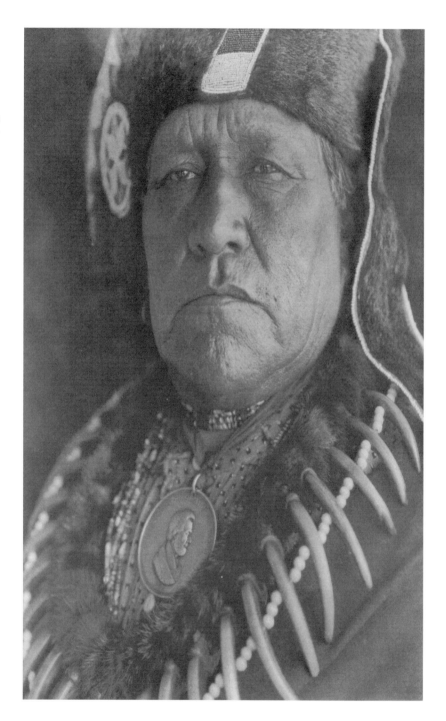

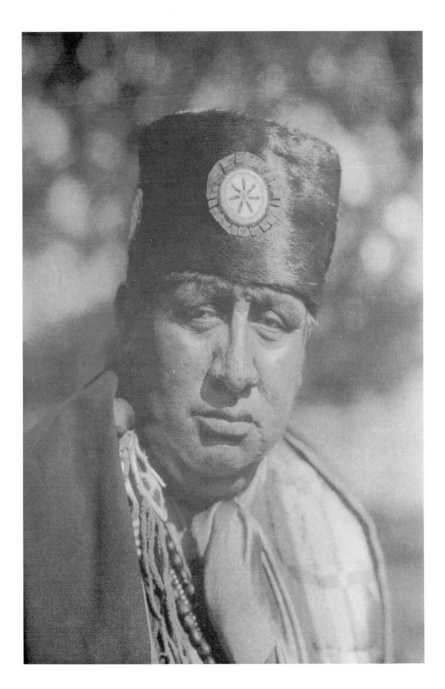

9. JOHN ABBOTT — OSAGE
©1927 (XIX, 680)

"The Osage . . . is a Siouian tribe—the wealthiest of all Indians and probably the richest people in the world, population considered. They are most closely related to the Omaha, Quapaw, Ponca, and Kansa, with whom they once formed a single body."

10. Prayer to the Mystery
©1907 (III, 91)

"In supplication the pipe was always offered to the Mystery by holding it aloft. At the feet of the worshipper lies a buffalo skull, symbolic of the spirit of the animal upon which the Indians were so dependent. The subject of the picture is Picket Pin, an Ogalala Sioux."

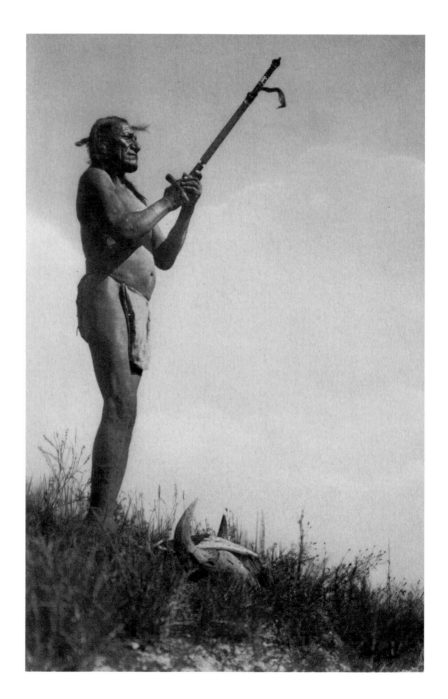

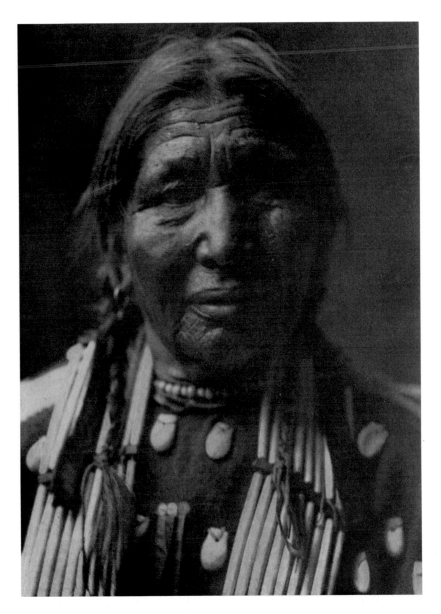

11. Ogalala Woman
©1907 (III, 94)

"A face so strong that it is almost masculine, showing strikingly how slight may be the difference between the male and female physiognomy in some primitive people."

12. SIOUX GIRL
©1907 (III, 97)

"A young Sioux woman in a dress made entirely of deerskin, embroidered with beads and porcupine quills."

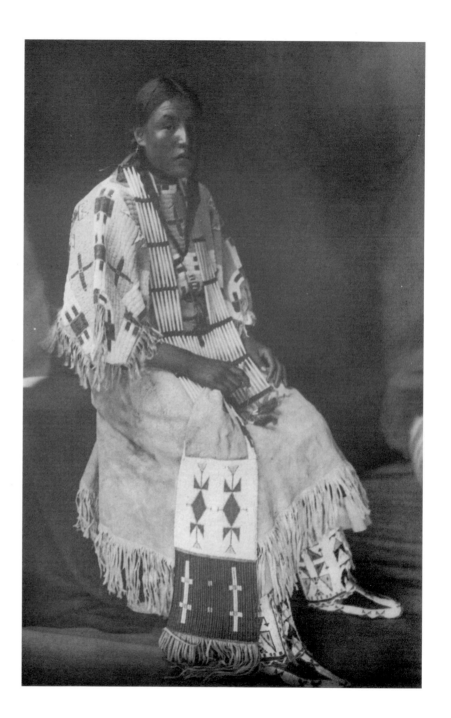

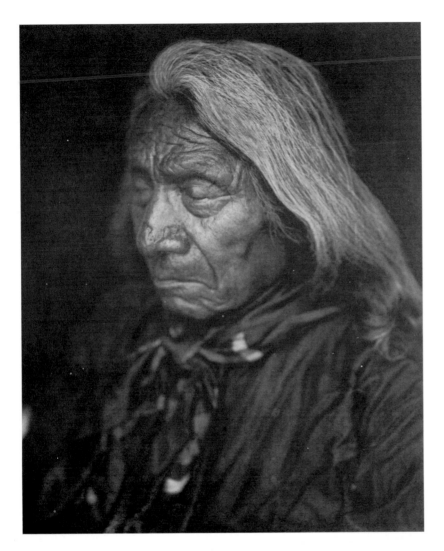

13. RED CLOUD—OGALALA
©1905 (III, 103)

"Ogalala. Born 1822. At the age of fifteen he accompanied a war-party which killed eighty Pawnee. . . . At seventeen he led a party that killed eight of the same tribe. During his career he killed two Shoshoni and ten Apsaroke. . . . Red Cloud received his name in recognition of his bravery, from his father after the latter's death. . . . He first gained notice as a leader by his success at Fort Phil. Kearny in 1866, when he killed Captain Fetterman and eighty soldiers. In the following year he led a large party, two to three thousand, . . . in an attack on a wood-train at the same post, but was repulsed with great loss. . . . Previously only Chief of the Bad Face band of Ogalala, he became head-chief of the tribe after the abandonment of Fort Phil. Kearny. Red Cloud was prevented from joining in the Custer fight by the action of General Mackenzie in disarming him and his camp." (volume 3, p. 187)

14. The Winter Camp—Sioux
©1908 (III, 106)

"With the coming of winter the plains tribes pitched their camps in forested valleys, where they were not only protected from the fierce winds of the plains, but had an ample supply of fuel at hand."

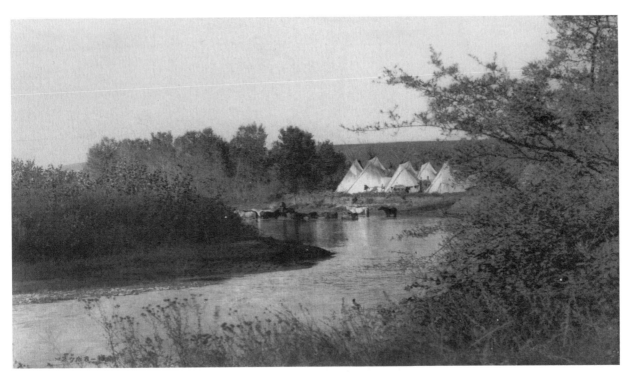

15. On the Little Bighorn —
Apsaroke
©1908 (IV, 114)

"This picturesque camp of the Apsaroke
was on Little Bighorn river, Montana, a
short distance below where the Custer
fight occurred."

16. PLACATING THE SPIRIT
OF THE SLAIN EAGLE — ASSINIBOIN
©1926 (XVIII, 634)

"For their feathers, which were used in
may ways as ornaments and fetishes, eagles
were once caught by a hunter concealed in
a brush-covered pit. A rather elaborate
ceremony took place over the bodies of
the slain birds for the purpose of placating
the eagle spirits. The Sarsi custom is
described at some length in volume [18],
pp. 95–99."

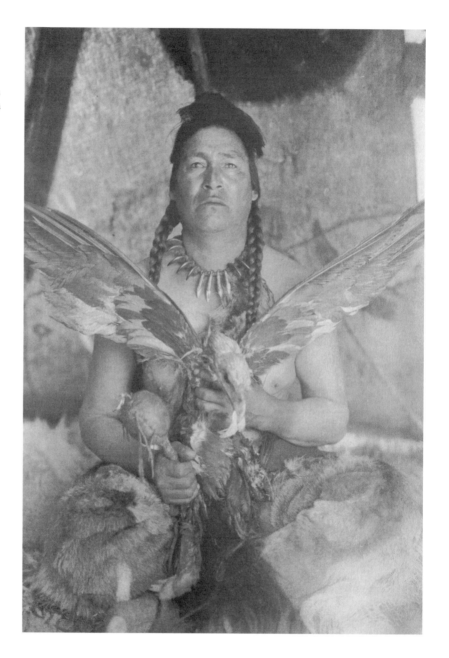

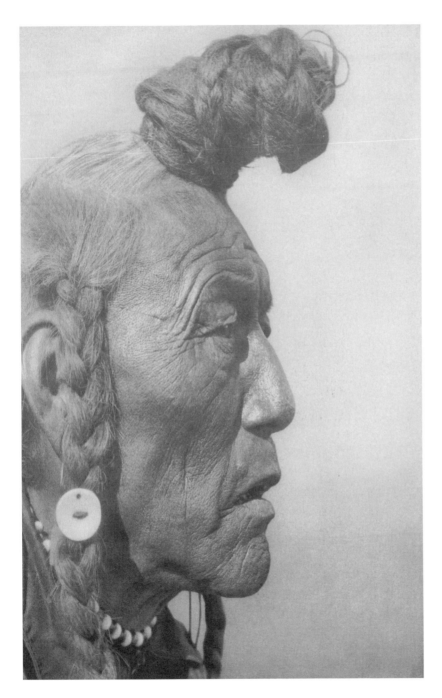

17. Bear Bull—Blackfoot
 ©1926 (XVIII, 640)

"The plate illustrates an ancient Blackfoot method of arranging the hair." (Bear Bull, also called Rain Chief, was born in 1859 between the Battle and Saskatchewan Rivers. He was Curtis's principal Blackfoot informant; among other things, he identified eleven named Blackfoot societies for the author-photographer. [summarized from volume 18, pp. 176, 188])

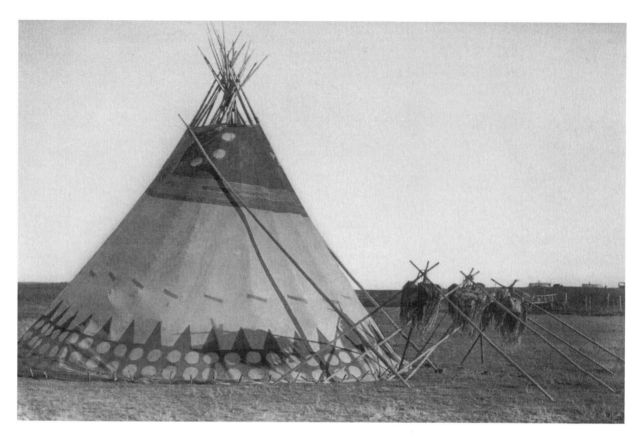

18. Lodge of the Horn Society—
 Blood
 ©1926 (XVIII, 645)

"The Horn Society is the custodian of a
cult about which the natives are loath to
give details. It stands apart from the
system of age-societies, which though
partly religious in character were more
concerned with warfare and the
preservation of order in camp. Numerous
taboos apply to the conduct of Horn
members, and there are sexual rites in
which the wife of a novice and his sponsor
participate."

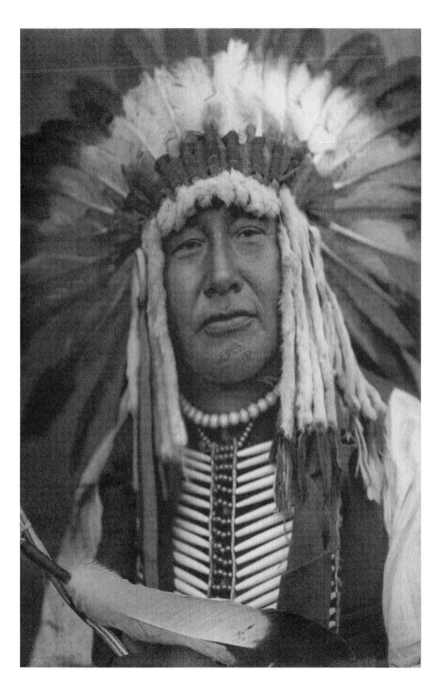

19. YELLOW OWL — MANDAN
©1908 (V, 148)

"A face approaching the type of pure
Mandan. The neck ornament consists of
beads and cylindrical bones, and from the
eagle feather war-bonnet hang numerous
weasel tails."

20. Red Whip—Atsina
©1908 (V, 174)

"Born 1858 near Fort McGinnis,
Montana. At the age of seventeen he went
out on his first war expedition, against the
Sioux . . . camped at Lodgepole Creek. . . .
Red Whip was in the lead of the charge
and took a few of the animals single
handed. During a battle with the Piegan
he rushed into the enemy's line and
captured a gun. . . . Red Whip was
scouting on the Tongue river with General
Miles when the Sioux charged the small
body of soldiers, routing them. Red Whip
said he stood firm and stopped the
onrushing enemy until the troops escaped.
His medicine, given to him by his uncle, is
a strip of otter fur." (volume 5, p. 183)

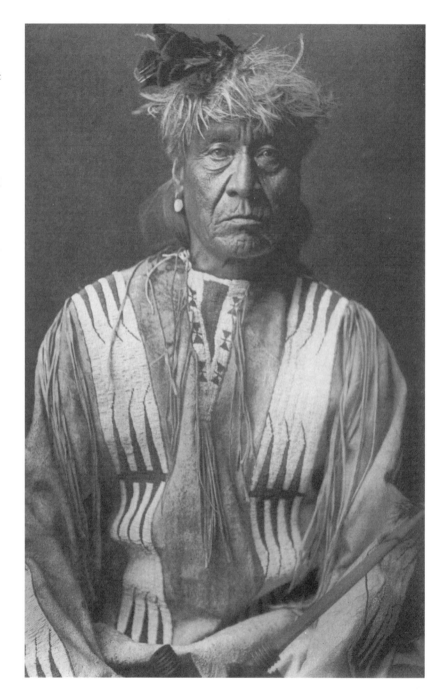

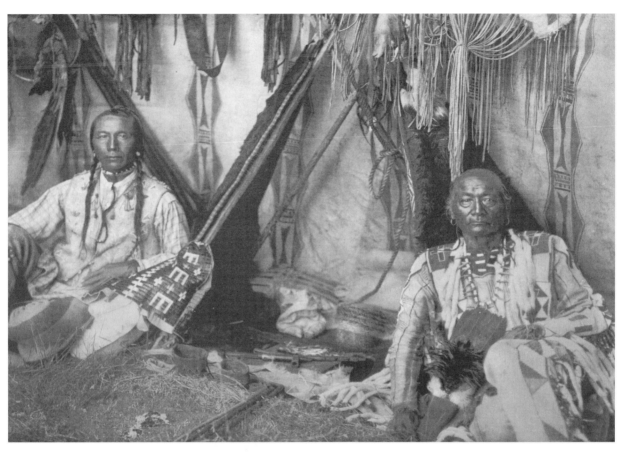

21. In a Piegan Lodge
©1910 (VI, 188)

"Little Plume with his son Yellow Kidney, occupies the position of honor, the space at the rear opposite the entrance. The picture is full of suggestions of the various Indian activities. In a prominent place lie the ever-present pipe and its accessories on the tobacco cutting-board. From the lodge-poles hang the buffalo-skin shield, the long medicine-bundle, an eagle-wing fan, and deerskin articles for accoutering the horse. The upper end of the rope is attached to the intersection of the lodge-poles, and in stormy weather, the lower end is made fast to a stake in the centre of the floor space."

22. Iron Breast — Piegan
©1900 (VI, 206)

"The picture illustrates the costume of a member of the Bulls (see volume [6], p. 28), and age society for many years obsolete."

"It [the Bulls] was formed, probably about 1820 by a man who, in a dream in the mountains, saw a certain kind of dance, and on his return made the necessary insignia, and sold it to a number of old men, and instructed them in the songs and dance. . . . Some . . . had war bonnets . . . others caps formed of the scalp of the buffalo with the horns, shortened. . . . All wore buffalo robes with the hairy side exposed. . . . Squatting on the ground the Bulls began to sing their songs and when the dance song was reached they arose and danced, imitating the movements of the buffalo." (volume 6, pp. 28–29)

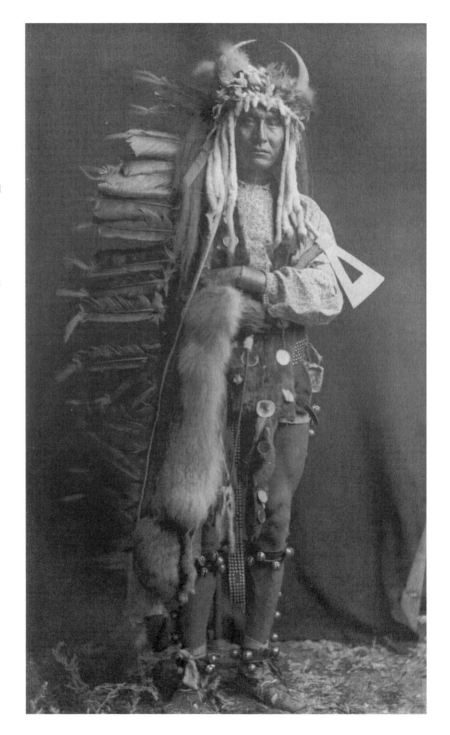

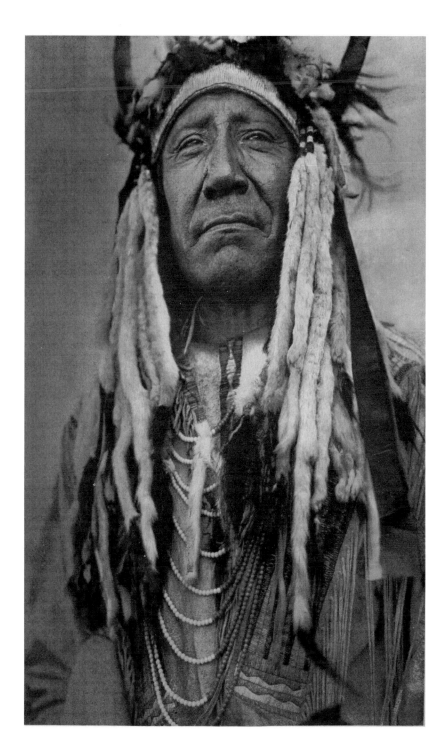

23. Two Moons — Cheyenne
©1910 (VI, 213)

"Two Moons was one of the Cheyenne war chiefs at the battle of the Little Bighorn in 1876, when Custer's command was annihilated by a force of Sioux and the Cheyenne."

24. WAITING IN THE FOREST —
 CHEYENNE
 ©1910 (VI, 218)

"At dusk in the neighborhood of the large
encampments young men closely wrapped
in non-committal blankets or white
cotton sheets, may be seen gliding about
the tipis or standing motionless in the
shadow of trees, each alert for the
opportunity to steal a meeting with his
sweetheart."

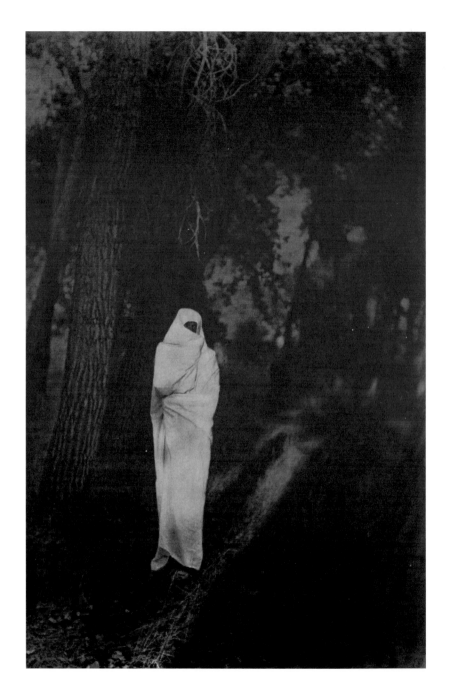

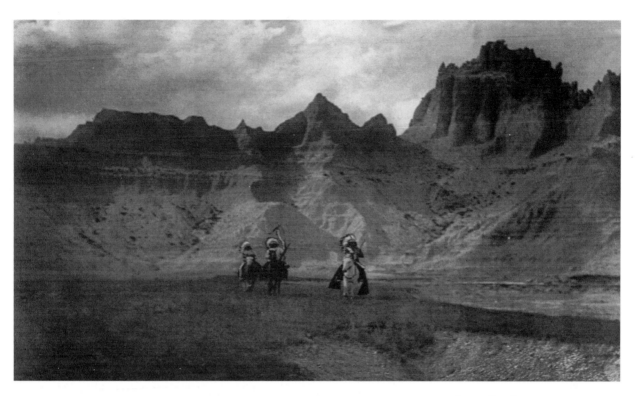

25. In the Bad Lands
©1904 (III, 119)

"This striking picture was made at Sheep Mountain in the Bad Lands of Pine Ridge reservation, South Dakota."

26. PLENTY COUPS — APSAROKE
©1908 (IV, 124)

"Born 1847. Mountain Crow of the
Whistle Water clan. When he was about
sixteen years of age his brother was killed
at Tongue river by the Sioux, and the boy
climbed for two days to reach a peak in the
Crazy mountains, there to give vent to his
grief and to pray for revenge. . . . He had at
that time already been on the war-path,
and now began to take the trail with great
frequency, so that at the age of twenty-six
he had counted a coup of each kind and
was called chief. . . . Subsequently his
record was four coups of each of four
sorts—striking the first enemy in a battle,
capturing a gun, taking a tethered horse
from the enemy's camp and leading a
successful war-party and as no other
Apsaroke could equal his achievements,
he became on the death of Pretty Eagle in
1903, chief of the tribe." (volume 4, pp.
203–4.)

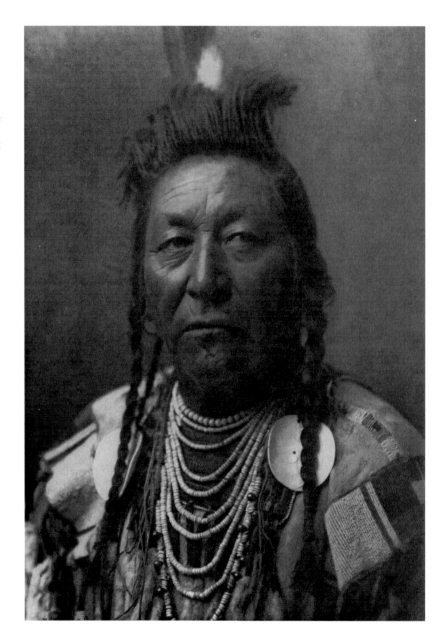

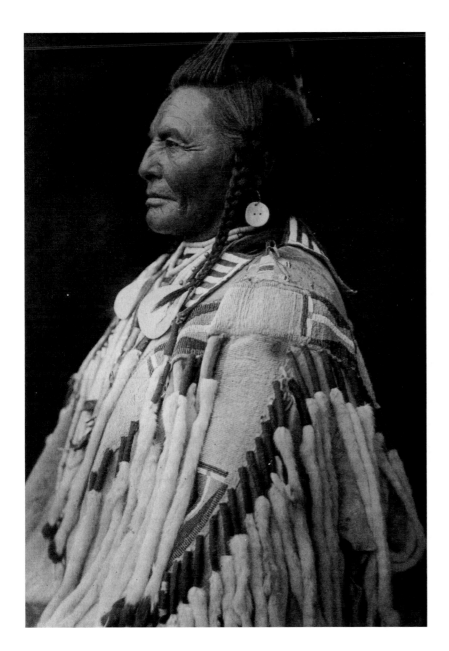

27. SHOT IN THE HAND—APSAROKE
©1908 (IV, 133)

"Born about 1841. Mountain Crow;
Whistle Water clan; Fox organization. By
fasting, he obtained his hawk-medicine. . .
. Counted three [first coups], captured
three guns, one tethered horse, but lacked
the medicine to become a war leader. . . .
Seven times he struck an enemy who was
firing at him. . . . Shot in the Hand played
a spectacular part in the battle against the
Sioux on Pryor creek. . . . On another
occasion he dismounted beside his father,
who had been shot in the thigh, and
though the latter was killed the son was
rescued, wounded in the arm. Four times
in as many different fights he seized an
unharmed enemy by the hair and hurled
him from his horse." (volume 4, p. 204)

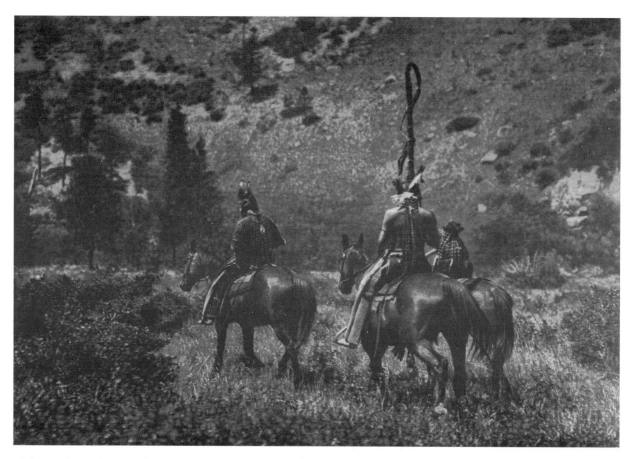

28. In the Black Cañon—Apsaroke
©1905 (iv, 136)

"The Apsaroke, although not exclusively
mountain dwellers, were ever fond of the
hills, preferring the forest shade and the
clear mountain streams to the hot, ill-
watered, monotonous prairies. The picture
illustrates the Apsaroke custom of wearing
at the back of the head a band from which
fall numerous strands of false hair
ornamented at regular intervals with
pellets of bright colored gum. Black Cañon
is in the northern portion of the Bighorn
mountains, Montana."

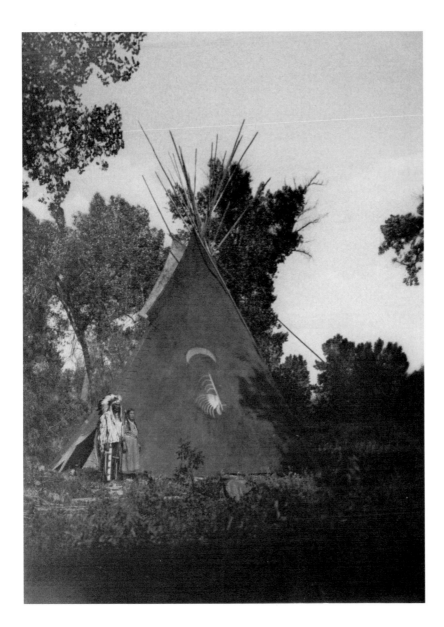

29. Apsaroke Medicine Tipi
©1905 (IV, 141)

"The Apsaroke medicine-men usually painted their lodges according to the visions received while fasting and supplicating their spirits. This tipi was painted dark red with various symbols on the covering. No man would dare so to decorate a tipi without having received his instructions in revelation from the spirits."

30. BEAR'S BELLY—ARIKARA
 ©1908 (v, 150)

"A member of the medicine fraternity, wrapped in his sacred bear skin."

"Born 1847, Fort Clark, in the present North Dakota. He had had no experience when at the age of fourteen he joined Custer's scouts at Fort Abraham Lincoln on the advice of old men of the tribe. . . . Shortly after Custer led his force into the Black Hills country, . . . there was a slight encounter with five tipis of Sioux, in the course of which the young Arikara counted two first coups and one second. . . . [Bear's Belly] became a member of the Bears in the medicine fraternity . . . connected with that event. . . . [Bear's Belly recounts how, in the] White Clay Hills, . . . 'Coming suddenly to the brink of a cliff, I saw below me three bears. . . . I wanted a bear, but to fight three was hard. . . . I waited until the second one was close to the first, and pulled the trigger. The farther one fell; the bullet had passed through the body of one and into the brain of the other. The wounded one charged, and I . . . shot again, breaking his backbone. . . . [T]he third bear . . . rose on his hind legs and I shot [him]. . . . The bear with the broken back was dragging himself. . . . I reloaded my gun and shot him. . . . His skin I kept, but the other two I sold.'" (volume 5, p. 178)

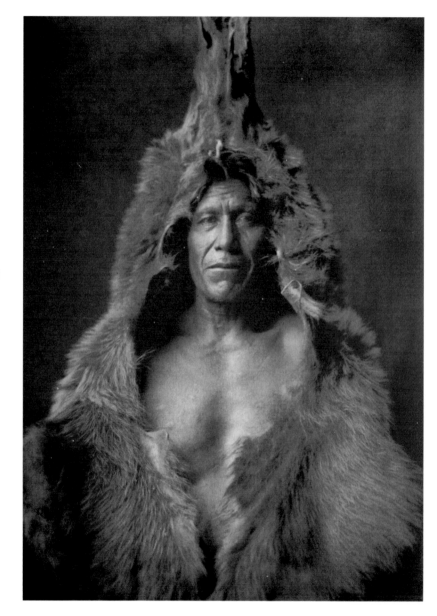

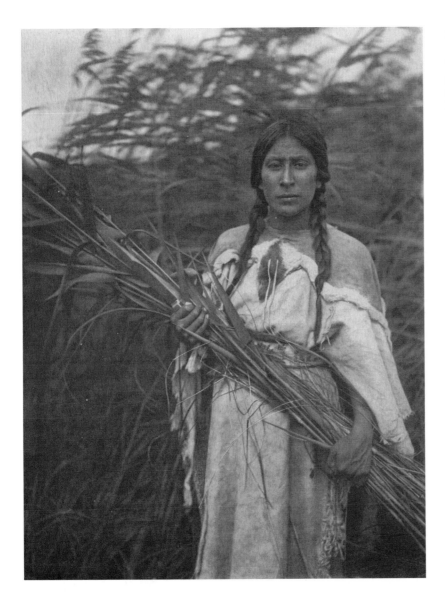

31. THE RUSH GATHERER—ARIKARA
©1908 (V, 160)

"The Arikara, as well as their close neighbors, the Mandan and Hidatsa, made many mats of rushes. These were used largely as floor coverings."

32. ARIKARA MEDICINE CEREMONY—
 THE DUCKS
 ©1908 (V, 163)

"Three members of the medicine
fraternity, painted to represent ducks and
holding the rushes among which
waterfowl nest, in their dance around the
sacred cedar."

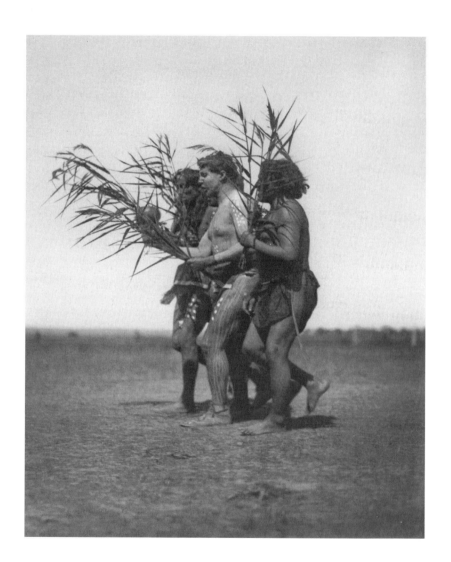

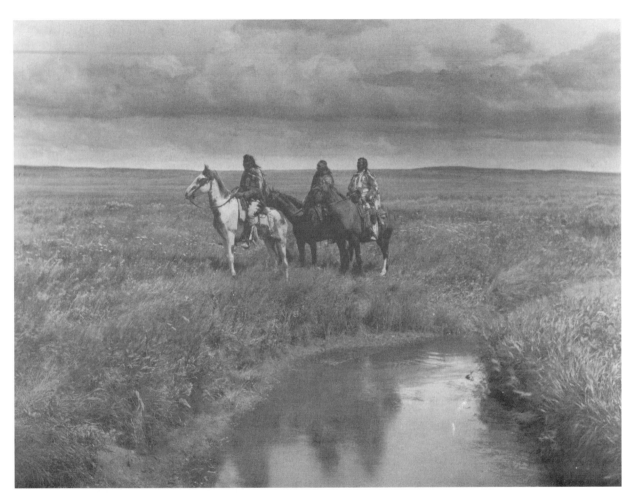

33. The Three Chiefs—Piegan
©1900 (vi, 209)

"Three proud old leaders of their people.
A picture of the primal upland prairies
with their waving grasses and limpid
streams. A glimpse of the life and
conditions which are on the edge of
extinction."

34. A SARSI CAMP
©1926 (XVIII, 620)

"The scene is a riverside grove near
Okotoks, Alberta, where a band of Sarsi
were awaiting clement weather to begin
the prosaic labor of shocking wheat for
one of their Caucasian neighbors."

35. The Moose Hunter—Cree
©1926 (XVIII, 623)

"Cree hunters are masters of the art of imitating, by means of a birch bark trumpet, the call of a moose of either sex, and thus luring within gunshot an animal seeking a mate during the rutting season."

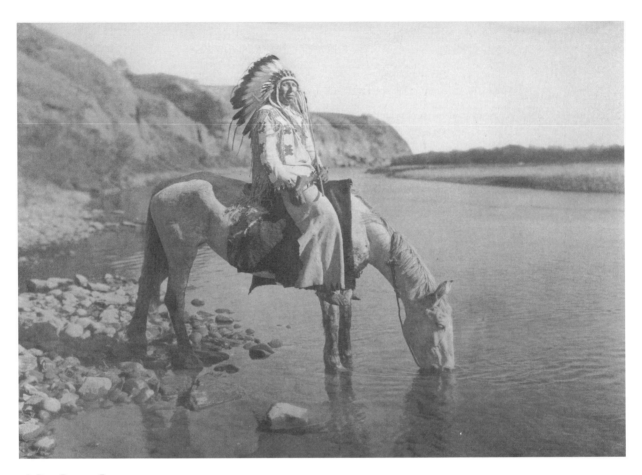

36. Bow River — Blackfoot
©1926 (XVIII, 644)

"In the earliest times of which living traditionists have information the Piegan ranged on Bow river, the Bloods on Red Deer river, the Blackfeet on the Saskatchewan. They gradually worked southward until the Blackfeet were on Bow, the Bloods on Belly, the Piegan on Old Man river and southward to the northern part of what is now Montana. In the summer the three tribes and the Sarsi always camped together for a time."
(volume 18, p. 187)

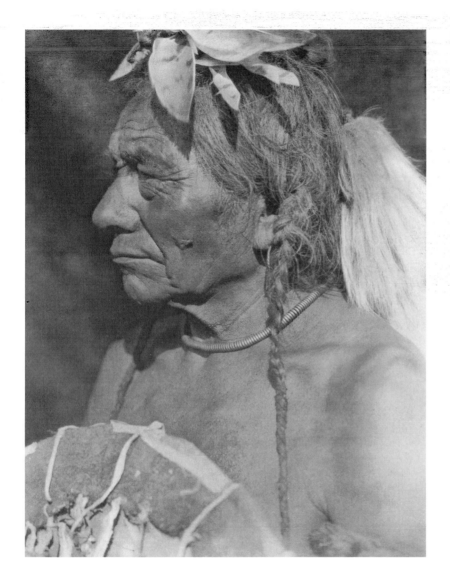

37. Makoyepuk ("Wolf Child") —
Blood
©1926 (XVIII, 647)

38. WALTER ROSS—WICHITA
©1927 (XIX, 657)

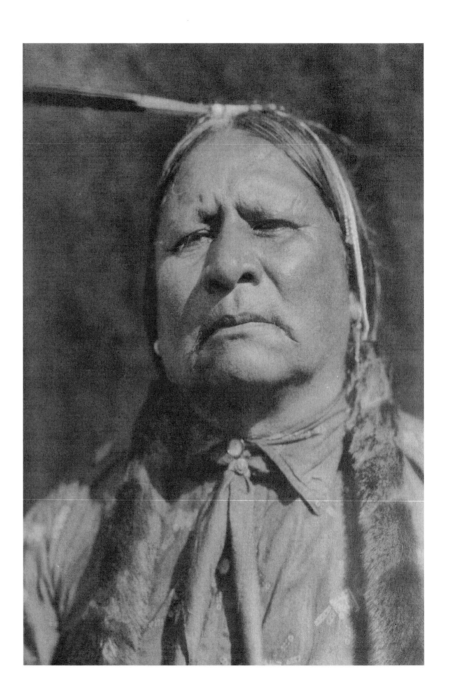

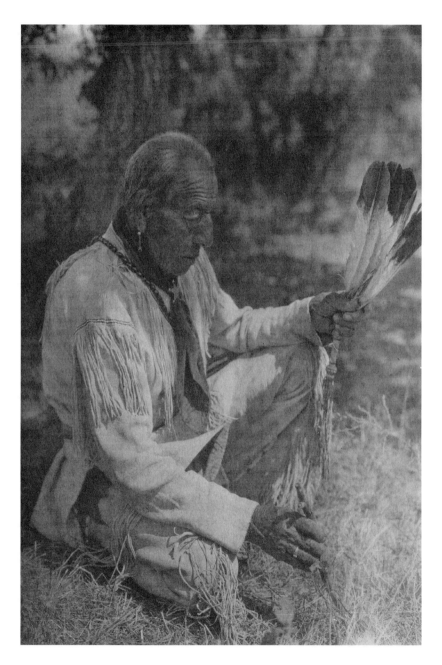

39. THE STORY OF THE WASHITA
 ©1927 (XIX, 658)

"An old Cheyenne warrior recounts the famous battle of the Washita in 1868, when the tribe was severely defeated by General Custer."

40. CHEYENNE COSTUME
 ©1927 (XIX, 666)

"This woman's deerskin costume,
ornamented with porcupine-quill
embroidery and with beads and fringe, is
characteristic of that of the Cheyenne; but
such is now worn only on gala occasions
and probably ere long will be a thing of
the past."

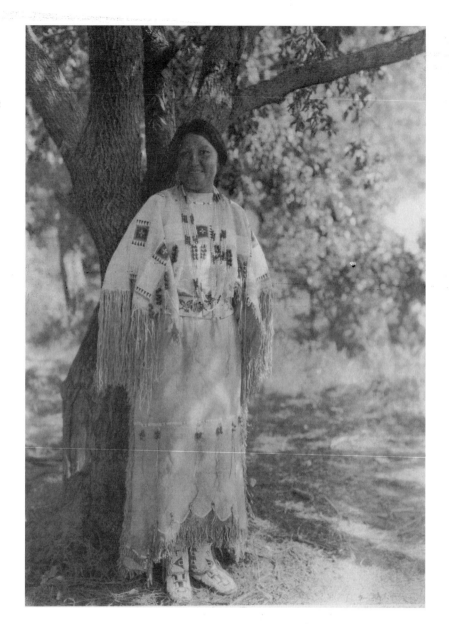

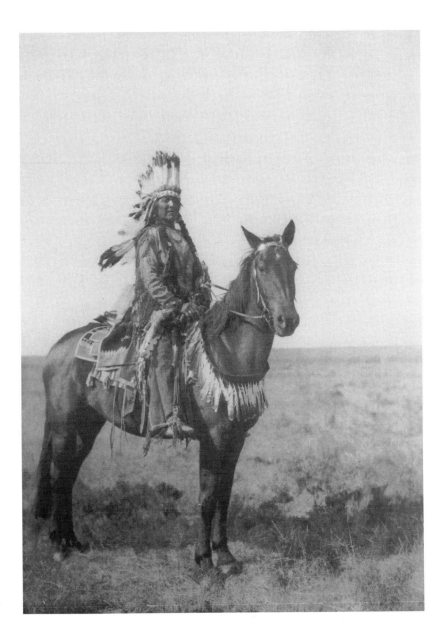

41. Black Man—Arapaho
©1927 (XIX, 674)

"By tradition the Arapaho once lived about the Red River valley of northern Minnesota. Historically they have been allied with the Cheyenne from about the beginning of the nineteenth century. . . . The main tribe of Arapaho, however, migrated in a southerly direction to the Black Hills of South Dakota. . . . A split in the band occurred about 1835, when they moved southward from Platte river. Part of the Cheyenne and part of the Arapaho departed down the Arkansas river, while the rest remained about the head of the North Platte. . . . [T]he two divisions have been known as Southern and Northern Arapaho respectively. The Northern Arapaho, who are now on the Wind River reservation in Wyoming, are considered to be the main body, since they have retained all their religious paraphernalia. The Southern Arapaho, together with the Southern Cheyenne, were placed on a reservation in Indian Territory in 1867; in 1892 they accepted allotments and their surplus lands were opened to settlement." (volume 19, pp. 14–15)

42. JOHN QUAPAW
(HÚNTA WAKÚNTA) — QUAPAW
©1927 (XIX, 681)

"The Quapaw are another Siouian tribe, otherwise known as Akansa from which the Arkansas river and state derive their name."

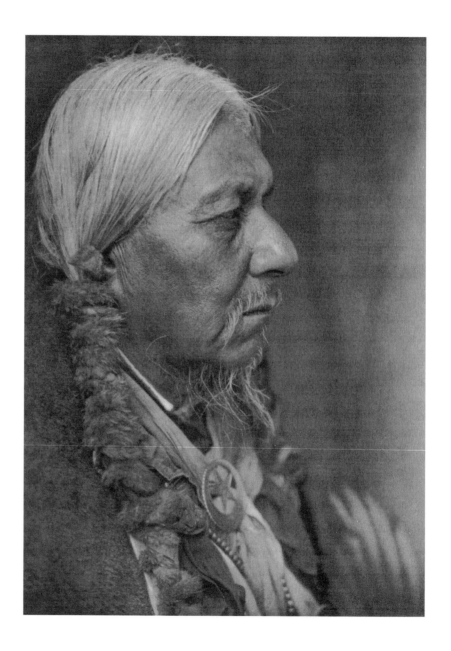

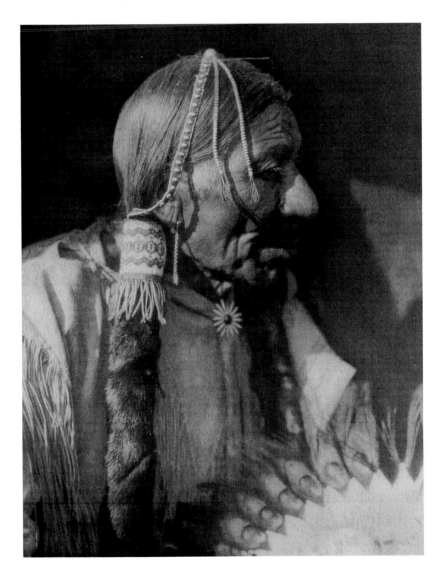

43. ÉSIPÉRMI—COMANCHE
©1927 (XIX, 682)

"There were no more vigorous people among the Indians of the Plains than the Comanche, a Shoshonean tribe, related to the Shoshone and Bannock of Idaho, from which region they entered the northern plains and drifted ever southward, following the bison in their wanderings. They were noted warriors and raiders, being the enemies of many tribes and extending their depredations into Mexico. One need only look no farther than the accompanying portraits to discern the warrior character of these old braves."

44. A Comanche Mother
©1927 (XIX, 685)

Curtis (volume 19, p. 186) quotes the following comments by Robert S. Neighbors, special agent to the Comanche, who communicated them to H. R. Schoolcraft, who in turn published them in his *Indian Tribes of the United States* (Philadelphia, 1860), 2:131–32: "The ties of consanguinity are very strong. . . . The women perform all manual labor, war and hunting being all the occupation of the men. . . . Their lodges are generally neat, and on the entrance of a stranger, the owner designates the route he shall pass, and the seat he shall occupy. . . . The children are named from some circumstance in tender years, which is frequently changed in after life by some act of greater importance."

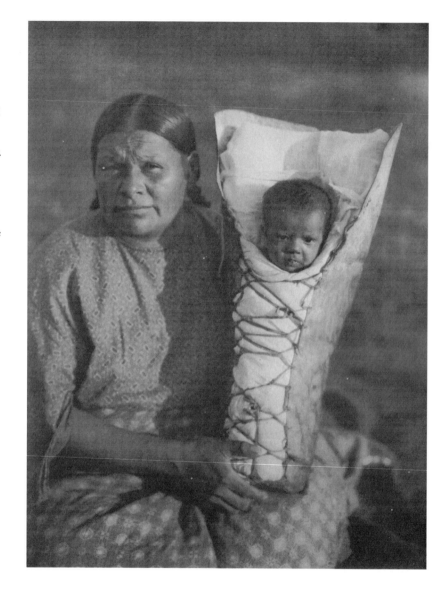

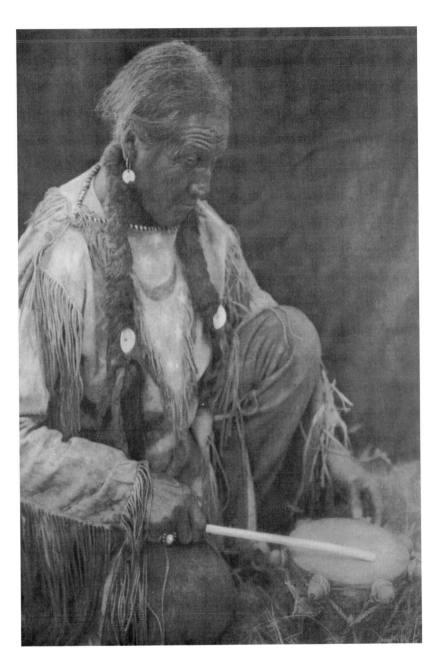

45. A PEYOTE DRUMMER
 ©1927 (XIX, 687)

"The Peyote rite as practiced by the Indians of Oklahoma is described in Vol. [19]. No Indian custom has been the subject of greater controversy or has led to the adoption of more laws and regulations with a view to abolishing it, largely because its effects have been misunderstood by white people."

"So far as can be determined, the formula of the songs is the same wherever the Peyote order exists. . . . [T]he ritual is obviously copied from Wichita ceremonial form. Most of the words of the songs and prayers are Comanche. The type of drum used is always the same—a small iron kettle partly filled with water and having a rawhide head. The beating of the drum is continuous throughout the rite, and its rhythmic vibration undoubtedly affects the emotions of the participants." (volume 19, pp. 200–201)

46. Horse Capture — Atsina
©1908 (v, 170)

"Born near Milk river 1858. . . . From their
camp at Beaver Creek the Atsina sent out
a war-party which came upon two Sioux.
Remaining hidden in a coulée, the
warriors sent an old man out as a decoy.
When the Sioux charged him, the rest of
the Atsina rushed out and killed them
both. During the fight, Horse Capture ran
up to one of the enemy, who was
wounded, in order to count coup, when
one of his companions dashed in ahead of
him and was killed by the wounded Sioux.
Horse Capture then counted first coup on
the enemy and killed him. He married at
the age of twenty-five." (volume 5, pp.
182–83)

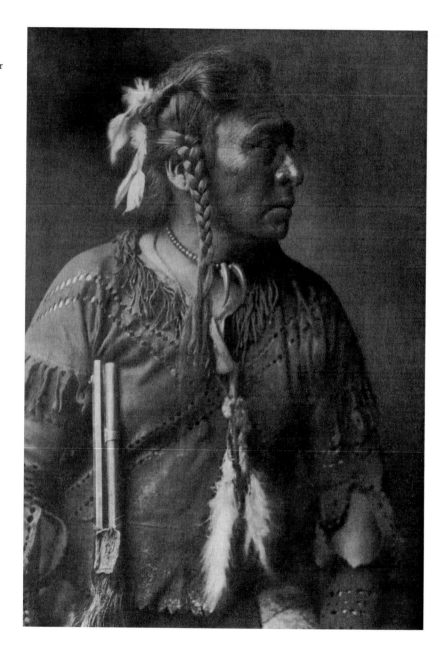

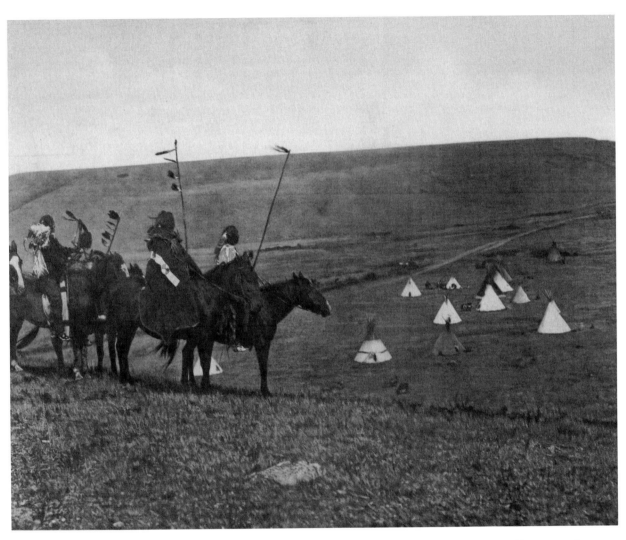

47. War-Party's Farewell — Atsina
©1908 (v, 178)

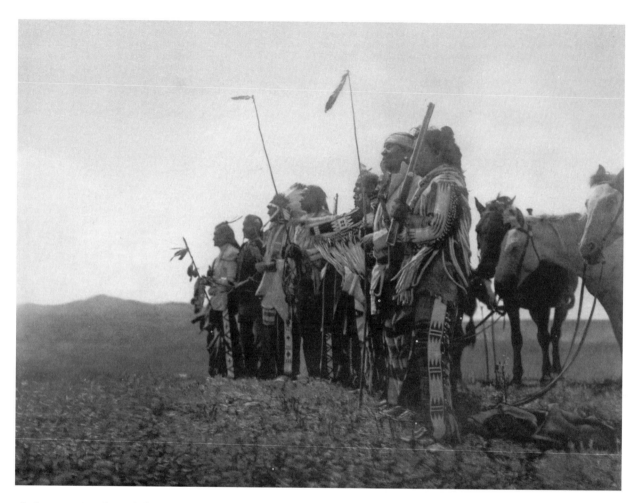

48. Awaiting the Scout's Return—
 Atsina
 ©1908 (v, 181)

"The war-party sent scouts far in advance,
who kept a constant lookout for the
enemy. From time to time they returned to
the main party to report, and when they
were sighted the warriors formed a line
and chanted a song of welcome."

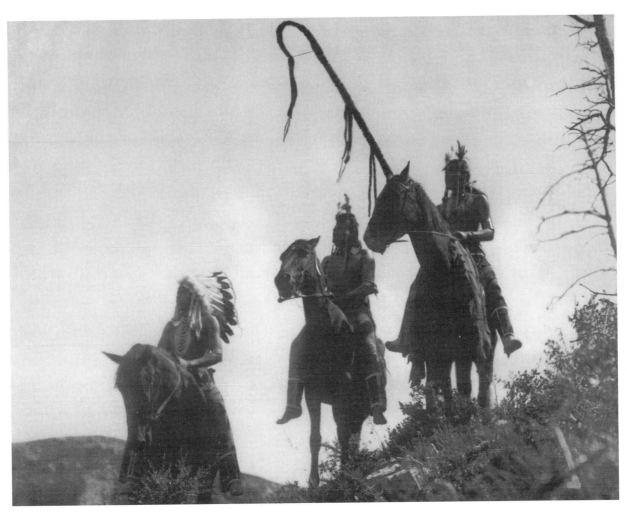

49. APSAROKE WAR GROUP
©1905 (IV, 147)

"The warrior at the right holds the curved
staff of one of the tribal military
organizations, which, at the crisis of a
fight, was planted in the ground as a
standard behind which the bearer was
pledged not to retreat."

50. SPOTTED BULL—MANDAN
©1908 (V, 149)

"Not a true Mandan type. The face shows
evidence of alien blood, possibly Dakota."

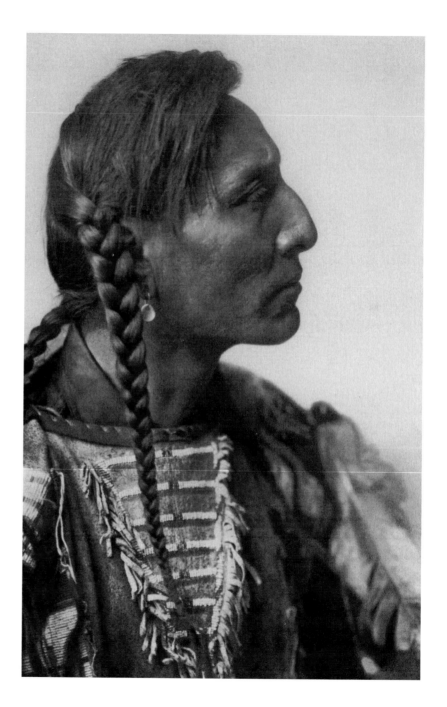

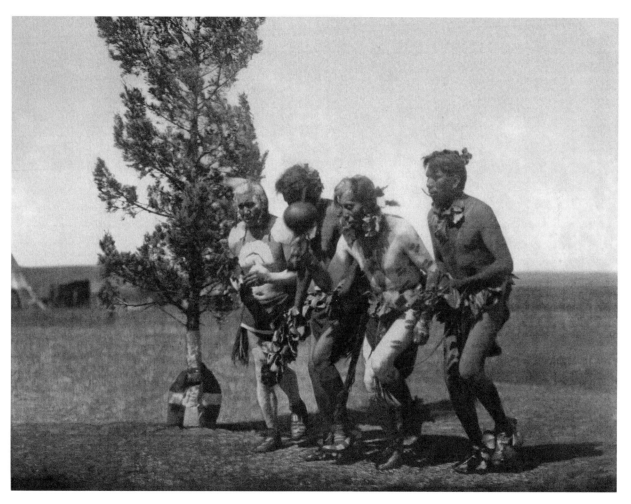

51. ARIKARA MEDICINE CEREMONY—
DANCE OF THE BLACK-TAIL DEER
©1908 (V, 162)

"The two dark figures are painted in a
manner suggesting the elk, the others the
antelope."

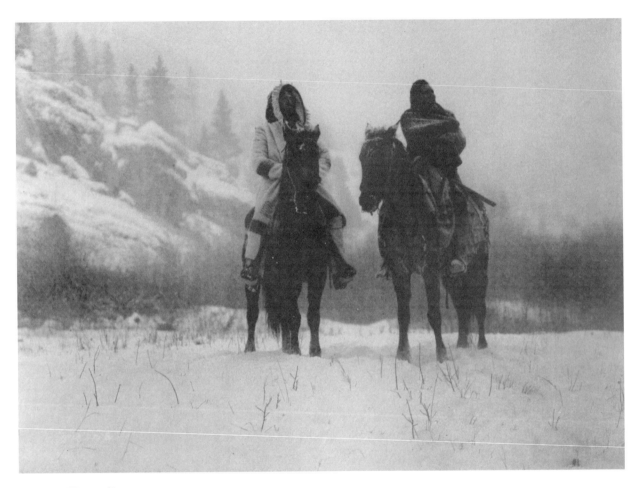

52. FOR A WINTER CAMPAIGN—
APSAROKE
©1908 (IV, 129)

"It was not uncommon for Apsaroke war-
parties, mounted or afoot, to move against
the enemy in the depth of winter. The
warrior at the left wears the hooded
overcoat of heavy blanket material that
was generally adopted by the Apsaroke
after the arrival of traders among them.
The picture was made in a narrow valley
among the Pryor mountains, Montana."

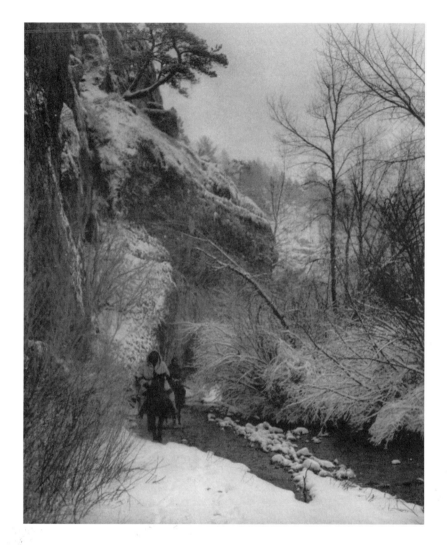

53. PASSING THE CLIFF — APSAROKE
©1908 (IV, 132)

"A winter scene on Pryor Creek,
Montana."

54. UPSHAW—APSAROKE
©1905 (IV, 139)

"An educated Apsaroke, son of Crazy
Pend d'Oreille. Upshaw has assisted the
author in his field-work, collecting
material treating of the northern plains
tribes."

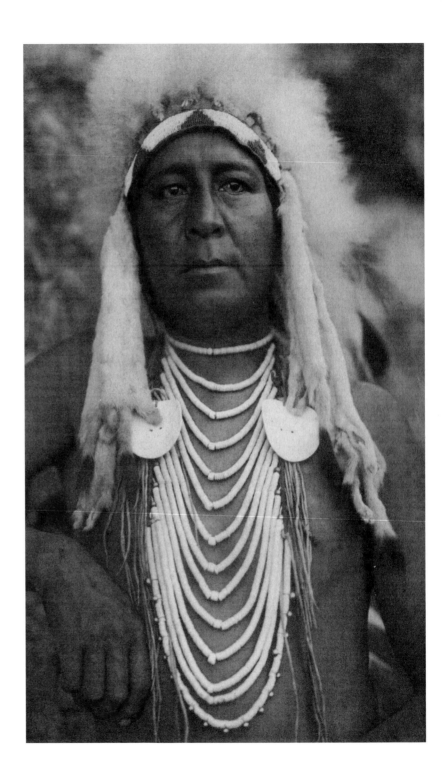

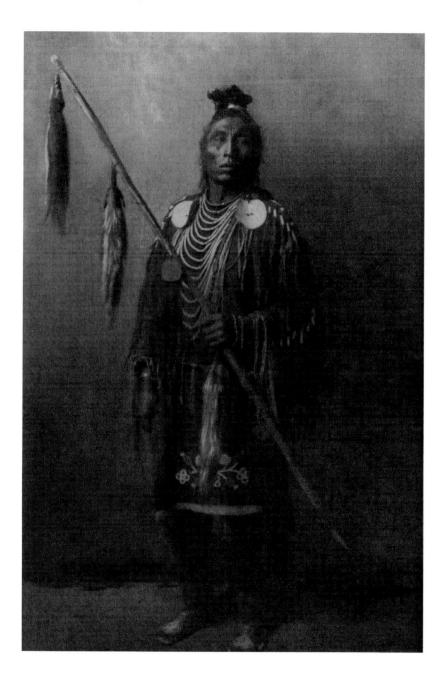

55. Apsaroke War Chief
©1908 (IV, 112)

"The three fox-tails hanging from the
coup-stick show the subject—Medicine
Crow—to be the possessor of three first
coups, that is, in three encounters he was
the first to strike one of the enemy's force.
The necklace consists of beads, and the
large ornaments at the shoulders are
abalone shells."

56. The Spirit of the Past
©1908 (IV, 122)

"A particularly striking group of old-time warriors, conveying so much of the feeling of the early days of the chase and the war-path that the picture seems to reflect in an unusual degree 'the spirit of the past.'"

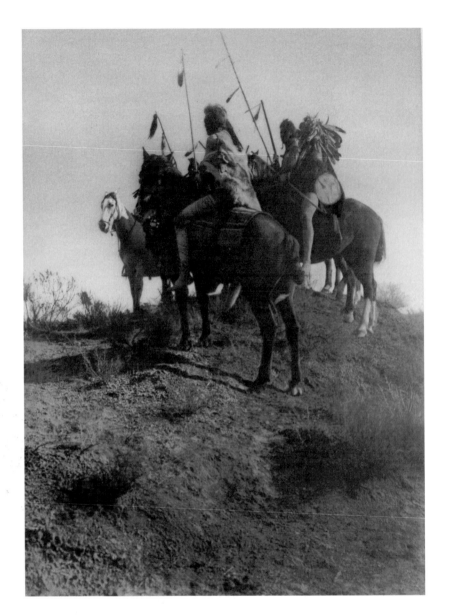

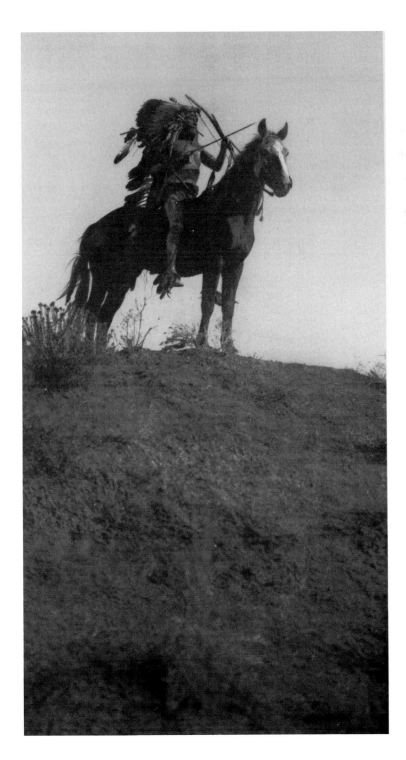

57. Ready for the Charge—
 Apsaroke
 ©1908 (IV, 125)

"The picture shows well the old-time
warrior with bow and arrow in position,
two extra shafts in his bow-hand, and a
fourth between his teeth ready for instant
use."

58. The Wood Gatherer—Sioux
©1908 (III, 105)

"Fuel for cooking and for warming the tipi was gathered and carried in by the women, as a part of their domestic work."

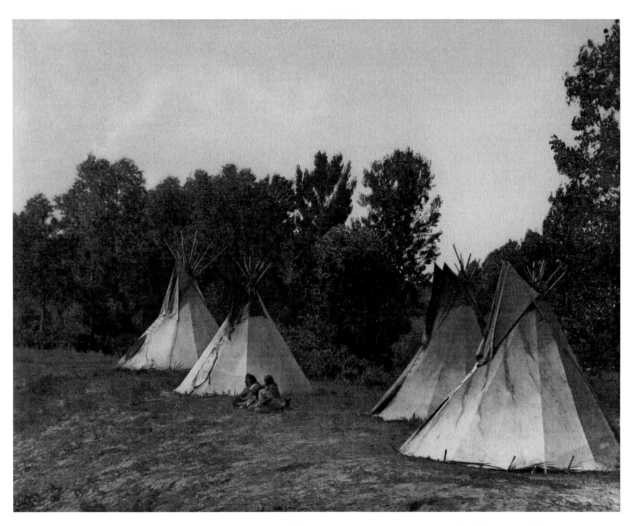

59. An Assiniboin Camp
©1908 (III, 107)

"In making their camps the Indians often choose the most picturesque spots."

60. TWO WHISTLES—APSAROKE
©1908 (IV, 111)

"Born 1856. Mountain Crow of the Not
Mixed Clan and Lumpwood organizations.
Never achieved a recognized coup, but at
the age of eighteen he led a party
consisting, besides himself, of two others,
which captured a hundred horses from the
Sioux. Participated in four severe battles
against Arapaho and Sioux. . . . [When
fasting] the first night he saw the war-
bonnet of a Sioux; the next day he cut the
skin and flesh of his arms in representation
of eight hoof-prints; and that night the
moon came to him and said, '[in the
country near Livingston, Montana] are
buffalo and horses mixed; you will never
be poor.' In the outbreak caused by the
medicine man Wraps Up His Tail, at Crow
Agency in 1887, Two Whistles was shot in
the arm and breast, necessitating the
amputation of the arm above the elbow.
His medicine of hawk was purchased with
a horse from a Sioux." (volume 4, p. 107)

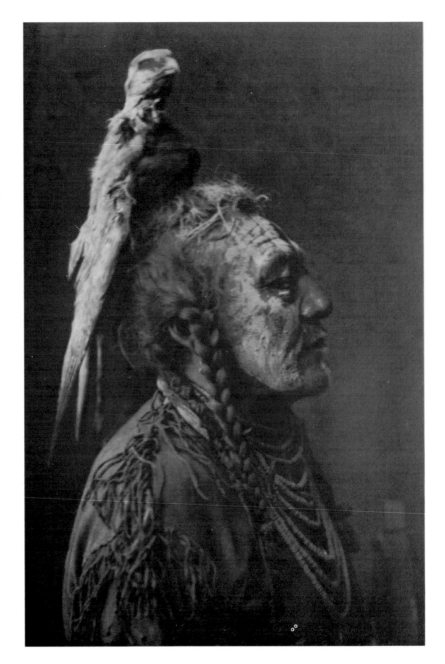

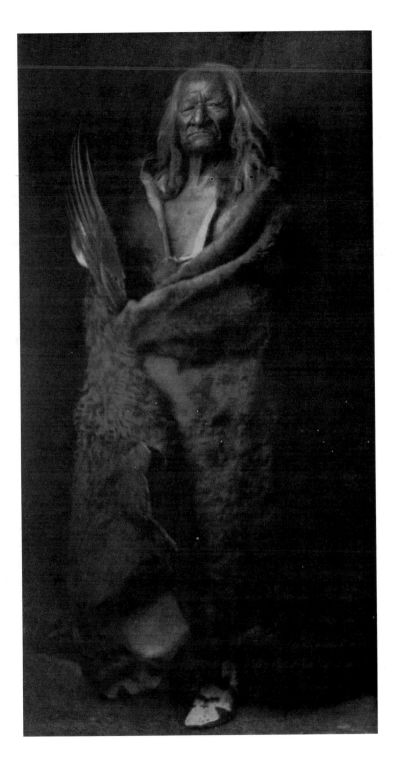

61. BLACK EAGLE—ASSINIBOIN
©1908 (III, 101)

"Born 1834 on the Missouri, below
Williston, North Dakota. He was only
thirteen years of age when he first went to
war. . . . On his fourth war excursion he . .
. [captured] six horses of the Yanktonai.
While engaged in a fight with the Atsina
near Fort Belknap, Montana, he killed one
of the enemy, and in another repeated the
former success. Black Eagle led war-parties
three times. He had a vision in which was
revealed to him that he would capture
horses, and the vision was fulfilled. He had
the same experience before he killed the
man and boy. He claims no medicine. He
married at the age of eighteen." (volume 3,
p. 182)

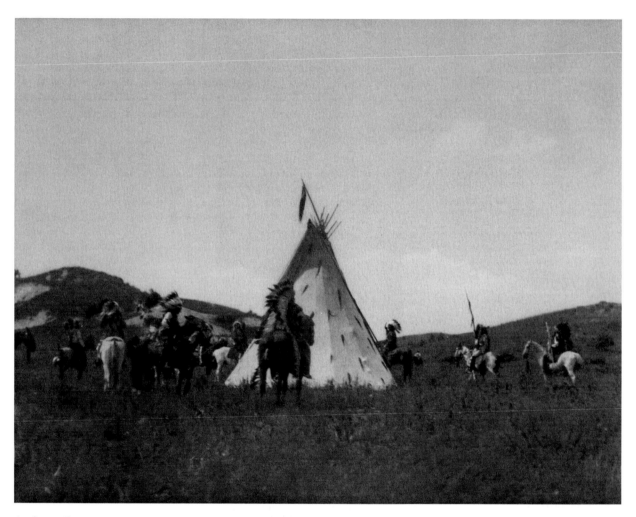

62. Sioux Camp
©1907 (III, 93)

"It was customary for a war-party to ride in
circles about the tipi of their chief before
starting on a raid into the country of the
enemy."

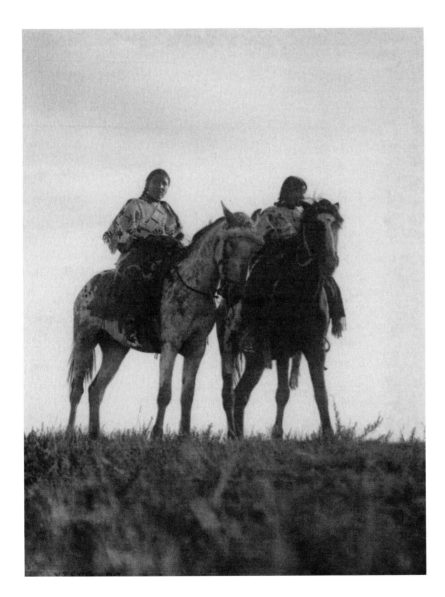

63. Ogalala Girls
©1907 (III, 96)

"As a rule the women of the plains are natural horsewomen and their skill in riding is scarcely exceeded by that of the men. As mere infants they are tied upon the backs of trusty animals, and thus become accustomed to the long days of journeying."

64. JACK RED CLOUD
©1907 (III, 81)

"The subject of this portrait is the son of the Ogalala chief Red Cloud."

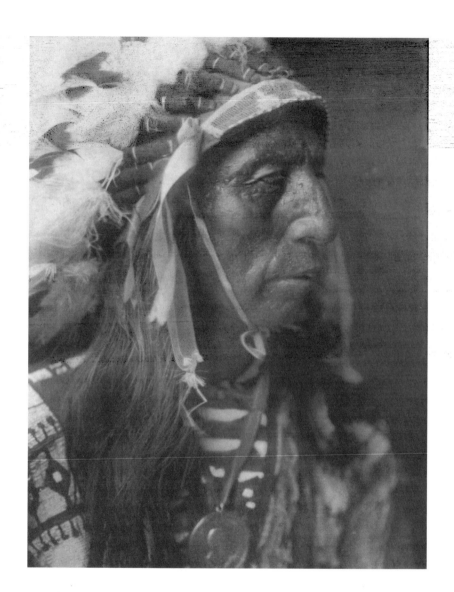

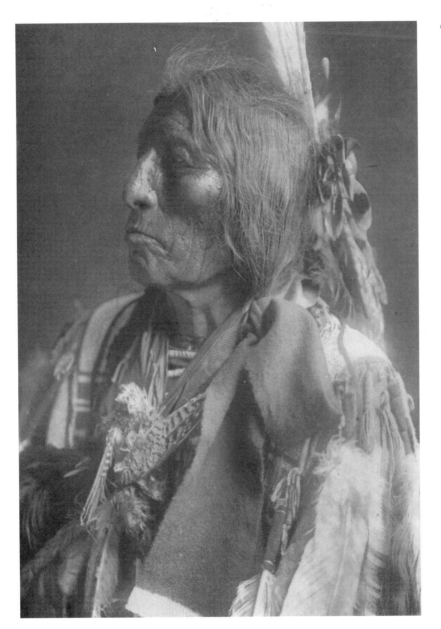

65. Slow Bull—Ogalala
©1907 (III, 84)

66. Little Hawk
 ©1908 (III, 89)

"This portrait exhibits the typical Brulé physiognomy."

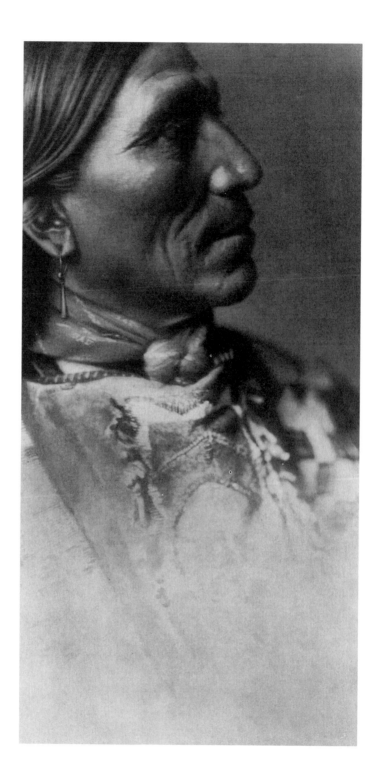

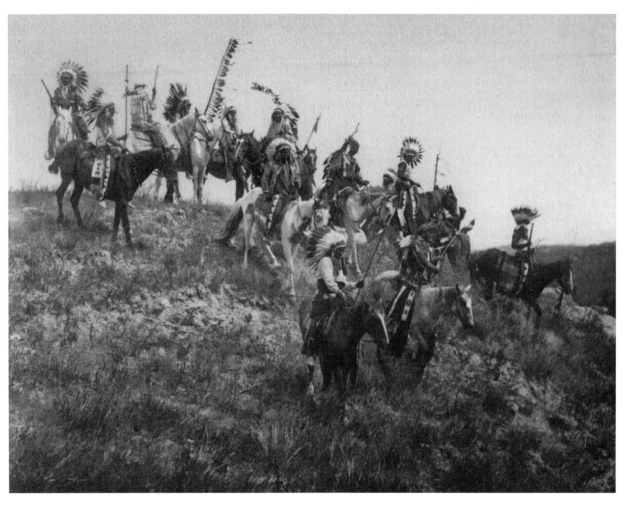

67. OGALALA WAR PARTY
©1907 (III, 77)

"Here is depicted a group of Sioux warriors
as they appeared in the days of intertribal
warfare, carefully making their way down
a hillside in the vicinity of the enemy's
camp. Many hold in their hands, instead
of weapons, mere sticks adorned with
eagle-feathers or scalps—the so-called
coup-sticks—desiring to win honor by
striking a harmless blow therewith as well
as to inflict injury with arrow or bullet."

68. HUNKÁ-LOWANPI CEREMONY
 ©1907 (III, 90)

"The subject of this picture is Saliva, an Ogalala Sioux, a priest of the Hunká-Lowanpi ceremony, which is fully described in Volume [3], p. 71–87."

"The name of the Hunká-lowanpi ceremony is derived from *hunká*, a term of respect for one's parents or ancestors, and *lowánpi*, they chant. . . . The principal purpose of the *Hunká-lowanpi* is to implant in the initiate the virtues of kindness, generosity, hospitality, truthfulness, fairness, honesty. At the same time it is a prayer for continued prosperity—for abundance of food, for health, strength, and moral well-being as a people.

 "*Hunká-lowanpi* is usually observed for a child who has been near to death, whose recovery is regarded at the result of the father's solemn promise to worship the Mystery by means of these rites." (volume 3, p. 71)

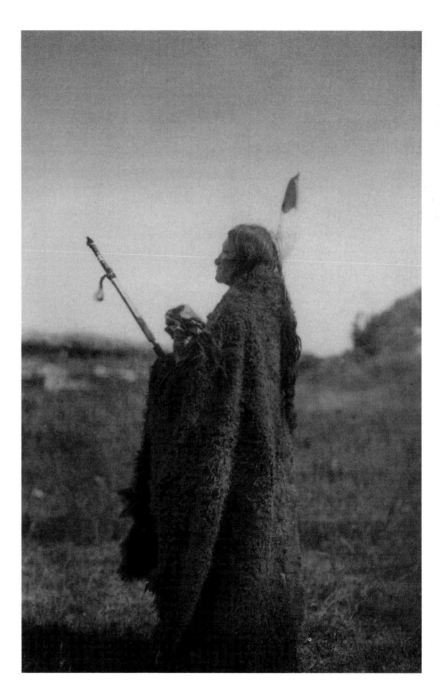

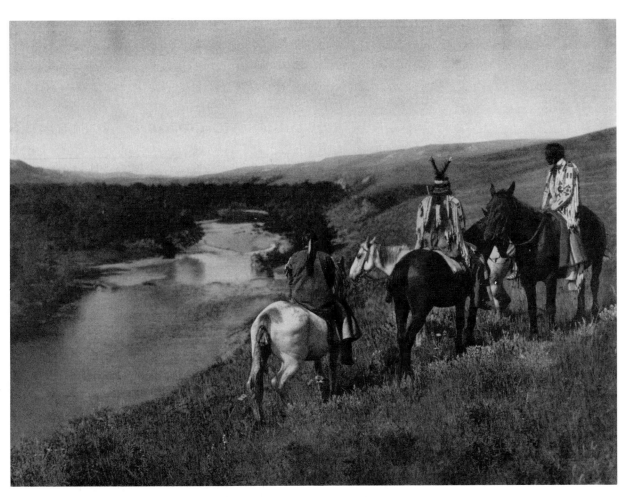

69. The Piegan
©1910 (VI, 184)

"This scene on Two Medicine river near
the eastern foothills of the Rocky
mountains is typical of the western portion
of the Piegan country, where the
undulating upland prairies become rougher
and give place abruptly to mountains."

70. TEARING LODGE—PIEGAN
©1910 (VI, 187)

"Pínokiminŭksh is one of the few Piegan
of advanced years and retentive memory.
He was born about 1835 on Judith River
in what is now northern Montana, and
was found to be a valuable informant on
many topics. The buffalo-skin cap is a part
of his war costume, and was made and
worn at the command of a spirit in a
vision. The first fasting of Tearing Lodge
for the sake of experiencing a vision is
narrated by him in Volume [6], pp. 79–81."

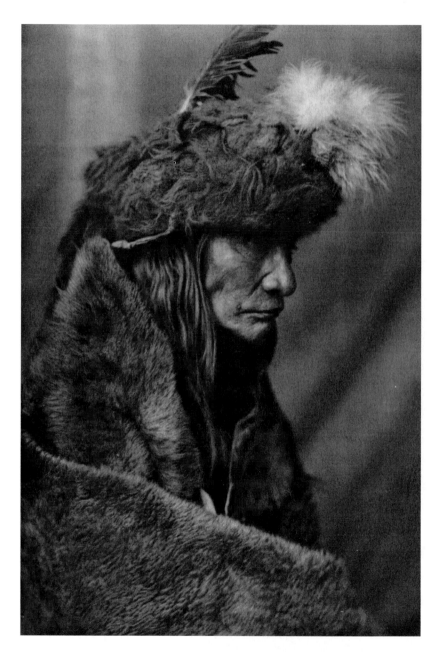

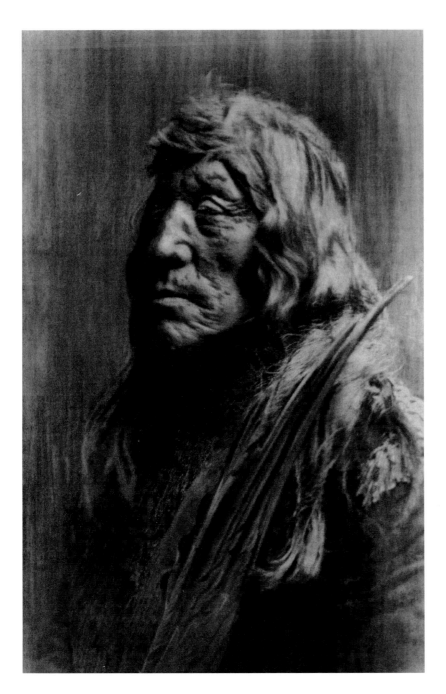

71. WHITE CALF — PIEGAN
©1900 (VI, 189)

"Unistaí-poka (White Buffalo-calf) died at
Washington in 1903. He was then almost
eighty years of age, and had been chief of
his tribe for about a generation. In 1855,
being then known as Feather, White Calf
was famous among the tribes, but with the
passing of intertribal warfare he devoted
himself to the working of peaceful ways for
the good of his people. He was remarkable
for his breadth of judgment and the
readiness with which he recognized and
adapted himself to changes that his people
had to face when the buffalo vanished.
Kindly, benevolent, gentle of nature,
White Calf yet possessed sturdy
determination and independence that
bullying and threats could not move. Yet if
reasons were advanced that appealed to
his judgment, he was quick to
acknowledge error and modify his views.
—George Bird Grinnell".

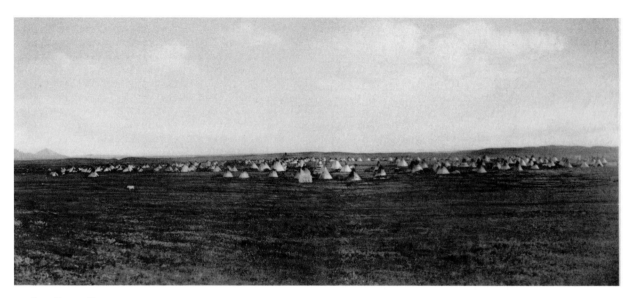

72. SUN DANCE ENCAMPMENT—
 PIEGAN
 ©1900 (VI, 192)

"This tribal assembly for the Sun Dance of
1898 comprised about two hundred and
thirty tipis, including a number of visiting
Blackfeet and Bloods from Canada. The
scene is on the Piegan reservation in
northern Montana, near Browning."

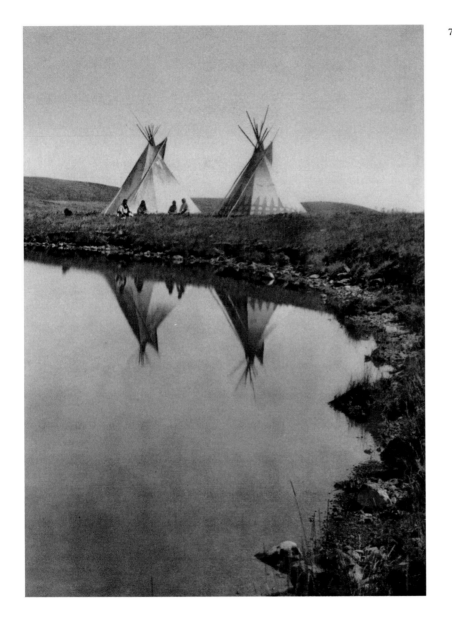

73. At the Water's Edge — Piegan
©1910 (VI, 195)

74. Yellow Kidney — Piegan
©1910 (VI, 196)

"The portrait shows Apuyótoksi (Light-colored Kidney) wearing a wolf-skin war-bonnet."

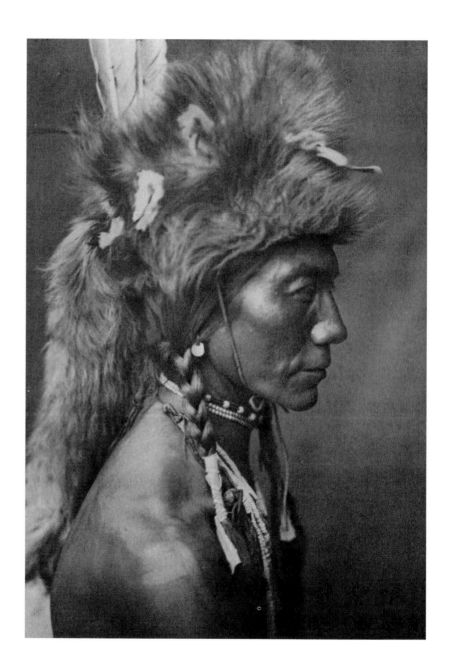

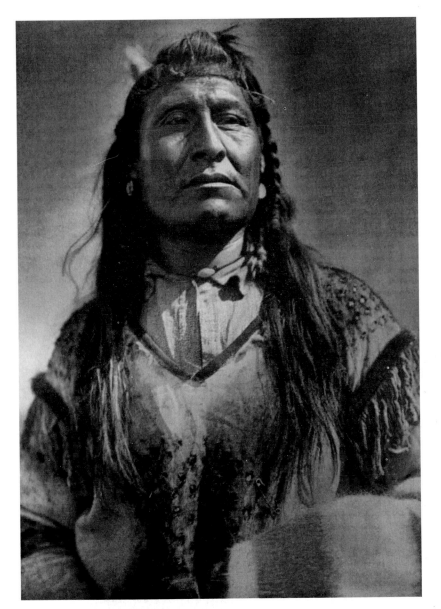

75. New Chest—Piegan
©1910 (VI, 200)

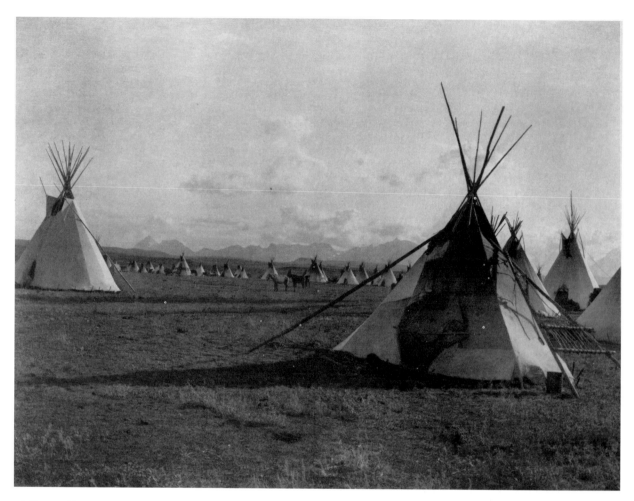

76. PIEGAN ENCAMPMENT
 ©1900 (VI, 207)

"The picture not only represents a
characteristic view of an Indian camp on
an uneventful day, but also emphasizes the
grand picturesqueness of the environment
of the Piegan, living as they do almost
under the shadow of the Rocky
Mountains."

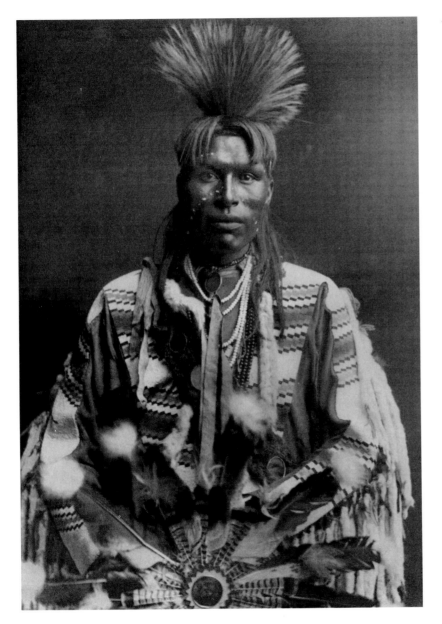

77. A Piegan Dandy
©1900 (VI, 208)

78. A Cree Girl
©1926 (XVIII, 622)

"The garment here illustrated is a robe of twined strips of rabbit-fur."

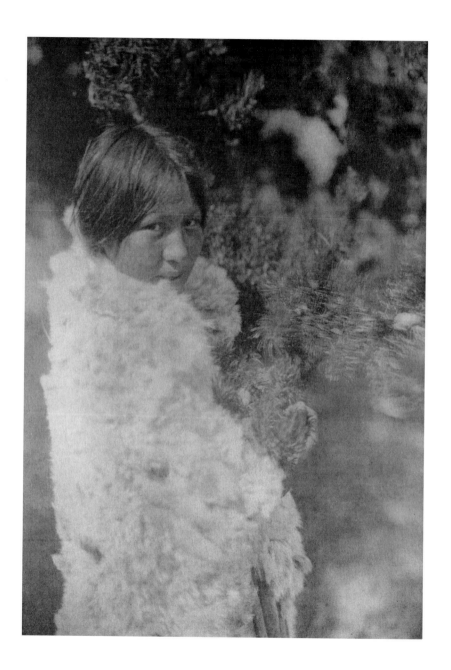

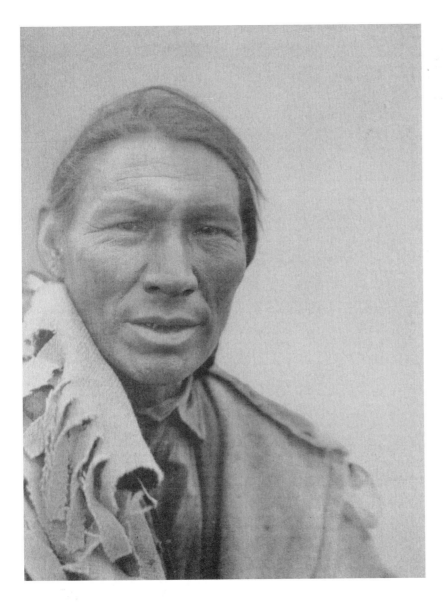

79. A Cree
©1926 (XVIII, 626)

"Of various widely differing types noted among the Cree at Lac les Isles, the subject of this plate and that of the following one were perhaps best representative of Cree physiognomy."

80. Assiniboin Hunter
©1926 (XVIII, 630)

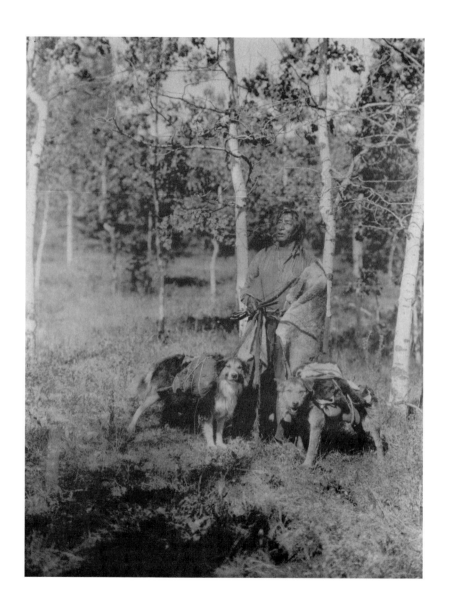

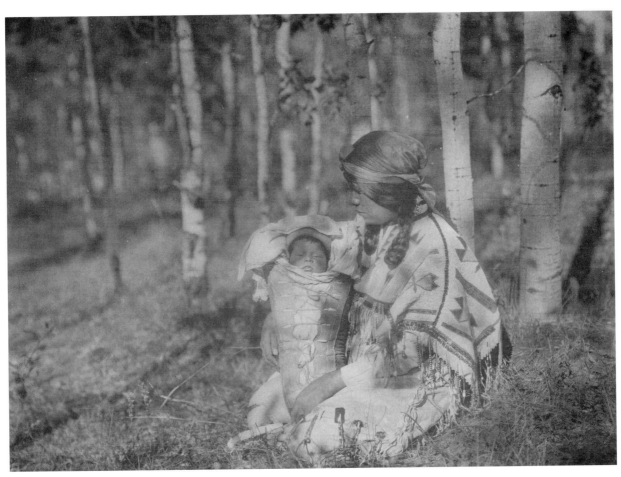

81. ASSINIBOIN MOTHER AND CHILD
©1926 (XVIII, 632)

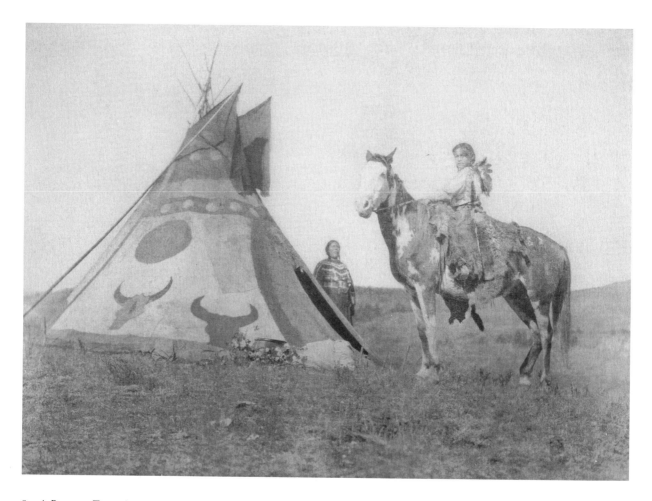

82. A Painted Tipi—Assiniboin
©1926 (xviii, 633)

"A tipi painted with figures
commemorative of a dream experienced
by its owner is a venerated object. Its
occupants enjoy good fortune, and there is
not difficulty in finding a purchaser when
after a few years the owner, according to
custom, decides to dispose of it."

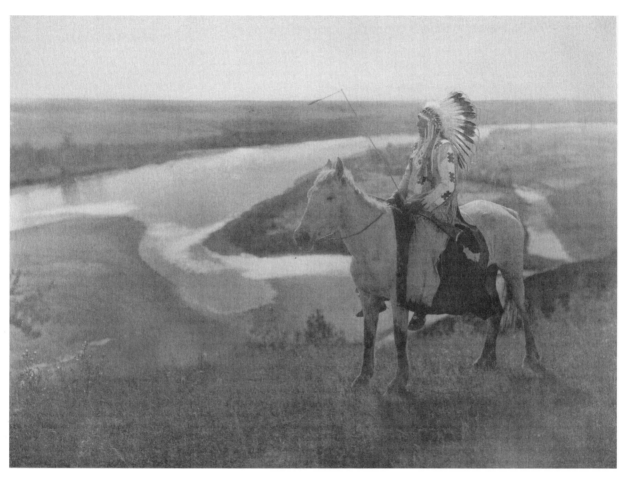

83. The Blackfoot Country
©1927 (XVIII, 636)

"Since the beginning of the historical period the Blackfeet have ranged the prairies along the Bow river, while their allies, the Bloods and Piegan, were respectively on Belly and Old Man rivers. In the earliest time of which their traditionists have knowledge the three tribes were respectively on Saskatchewan, Red Deer, and Bow rivers."

84. FLESHING A HIDE — BLACKFOOT
 ©1926 (XVIII, 643)

"The implement for removing flesh and fat
from hides is a long-bone with a beveled
scraping edge. The thong attached to the
upper end and passing about the woman's
wrist is for the purpose of giving additional
leverage."

85. Grass-House Ceremony—
Wichita
©1927 (XIX, 655)

"The rites performed at the building of a
grass-house are described in Volume [19],
p. 64–72."

86. On the Canadian River
©1927 (XIX, 659)

"The name of the Canadian river was not derived form any association with Canada or the Canadians, but from the Spanish *cañada*, on account of the high, cut banks of the stream. The Canadian originally divided the lands claimed by the Quapaw on the south and those of the Great and Little Osage on the north. The Indians in the picture are Cheyenne."

87. CHEYENNE SUN DANCE LODGE
©1927 (XIX, 660)

"For an account of the Sun-dance
ceremony, and the erection of the lodge
among the Southern Cheyenne, see
Volume [19], pp. 121–28."

88. A Cheyenne Chief
©1927 (XIX, 664)

"The Cheyenne belong to the Algonquian
linguistic family and therefore are related
to the tribes of the Blackfoot Confederacy
and to the Arapaho of the north, and
much more remotely, to many of the tribes
that once lived along the Atlantic
seaboard and in the Midwest. They are
now divided into the Northern Cheyenne,
living in Montana, and the Southern
Cheyenne who were assigned a reservation
in the present Oklahoma in 1867."

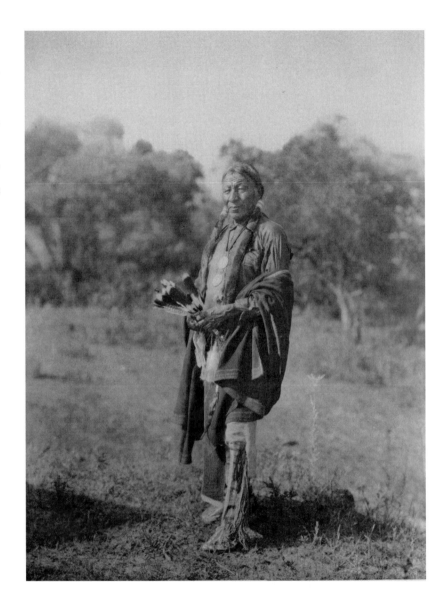

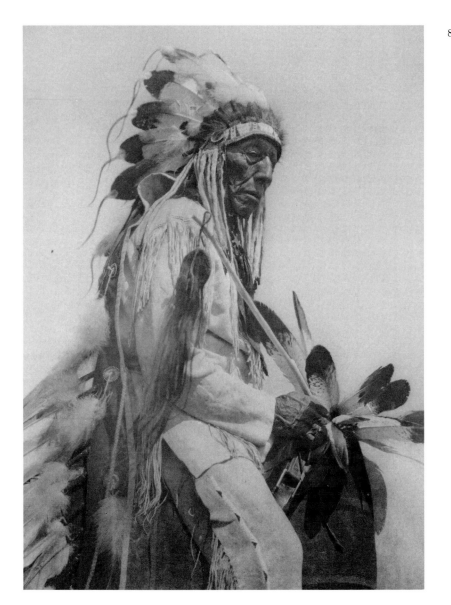

89. The Old Cheyenne
©1927 (XIX, 672)

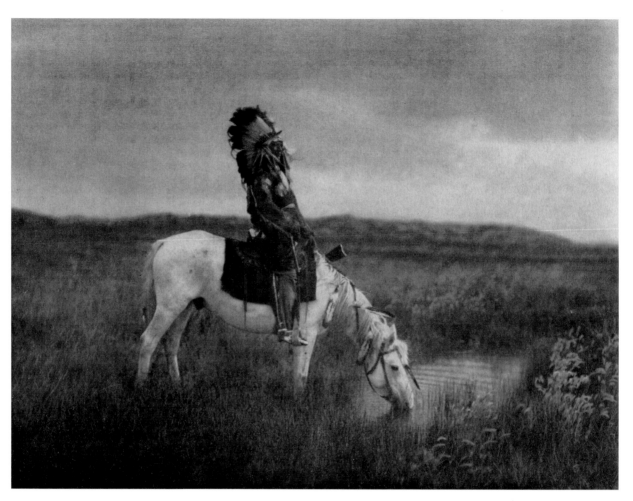

90. An Oasis in the Bad Lands
 ©1905 (III, 80)

"This picture was made in the heart of the
Bad Lands of South Dakota. The subject is
the sub-chief Red Hawk, a sketch of whose
life is given, p. 188, Volume [3]."

91. As It Was in the Old Days
©1927 (XIX, 652)

"In early days, before the white men invaded the Great Plains and ruthlessly slaughtered hundreds of thousands, bison were of prime importance to the hunting tribes of the vast region in which those animals had their range. The bison was not only the chief source of food of the Plains Indians, but its skin was made into clothing, shields, packs, bags, snowshoes, and tents and boat covers; the horns were fashioned into spoons and drinking vessels; the sinew supplied thread for sewing, bow-strings, and fibre for ropes; the hair was woven into reatas, belts, personal ornaments, and the covers of sacred bundles; and the dried droppings, 'buffalo chips,' were used as fuel. So dependent on the buffalo were these Indians that it became sacred to them, and many were the ceremonies performed for the purpose of promoting the increase of the herds."